AZZARO

FIFTY
SPARKLING
YEARS

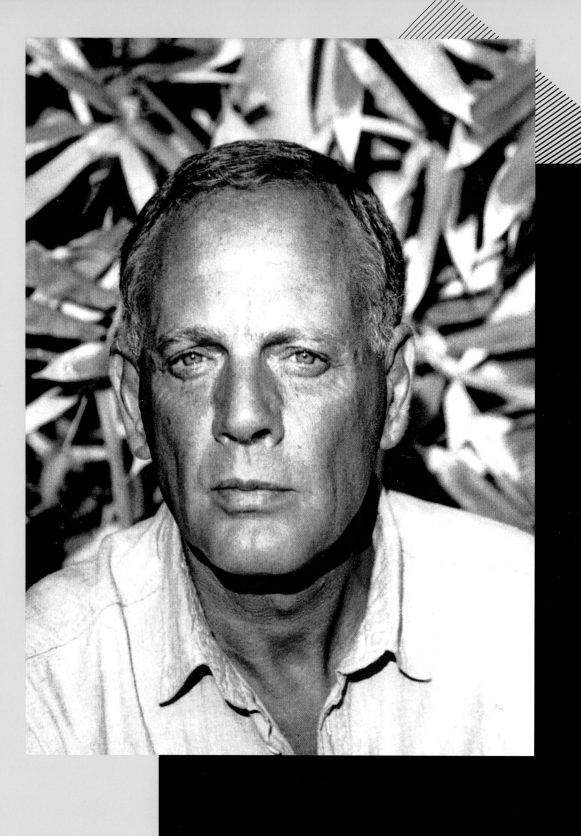

LORIS AZZARO
IN 1979.

AZZARO
FIFTY
SPARKLING
YEARS

TEXTS
SERGE GLEIZES

ABRAMS, NEW YORK

FOREWORD

I first got to know Loris Azzaro in the seventies when he was
making his name as a designer of belts and beaded purses.
I got to know him better some time later when I joined our family-
owned magazine, *L'Officiel de la Couture et de la Mode de Paris*.
He used to come into our offices in the Faubourg Saint-Honoré,
which were located just next to his boutique. Loris Azzaro was a tall,
handsome and imposing figure. He worked closely with my father,
Georges Jalou, who headed up the magazine in those days. From
those many meetings and work sessions came a friendship, and
countless articles that still exude nostalgia for those magical times.
Thanks to his jet-set connections, Loris Azzaro brought us a whole
host of celebrities who often graced the cover of *L'Officiel*, most
notably Marisa Berenson.
In those years, there was no real alternative to the rarefied world of
Haute Couture, so women had to spend a fortune on evening dress.
For Parisian women in particular, life was one long party and every
occasion demanded a new outfit. The bubbly flowed day and night,
fun was in the air and the carefree spirit was contagious. You worked
hard but you also played hard – maybe we were more naturally
ceremonious in those days.
Women longed to be beautiful and desirable and nobody fulfilled
their dreams better than Loris Azzaro. Here was luxury at a price
they could afford: sheath dresses, beaded jersey gowns and taffeta
dresses that were the last word in elegance, daringly modern but
unforgettably romantic.

Loris Azzaro dressed all the women of his time. He was a pioneer, an astute creator of a non-mainstream style that simply didn't exist before he came along. It was an unmistakable style – sexy, a little bit provocative and hugely influential on the generations that followed. It prefigured the sexually explicit spirit of the early 2000s. Loris Azzaro left a legacy that continues to flow fashion today – the cult of silhouette and architectural lines; the art of fashion draping using fluid jersey and embroidery; the glittering appeal of silver fabrics, and the enduring elegance of black and white.

I had the pleasure of wearing his dresses at many grand Parisian soirées – mainly taffeta gowns that would transform your silhouette. It was fun to play the game, slip into the skin of a star, a femme fatale or an arch-seductress. Even today, despite all the different trends that have taken root since his death in 2003, Azzaro's name remains synonymous with glamour, joie de vivre and a certain glittering, joyful idea of life.

Marie-José Susskind-Jalou
Director of editorial content, Editions Jalou

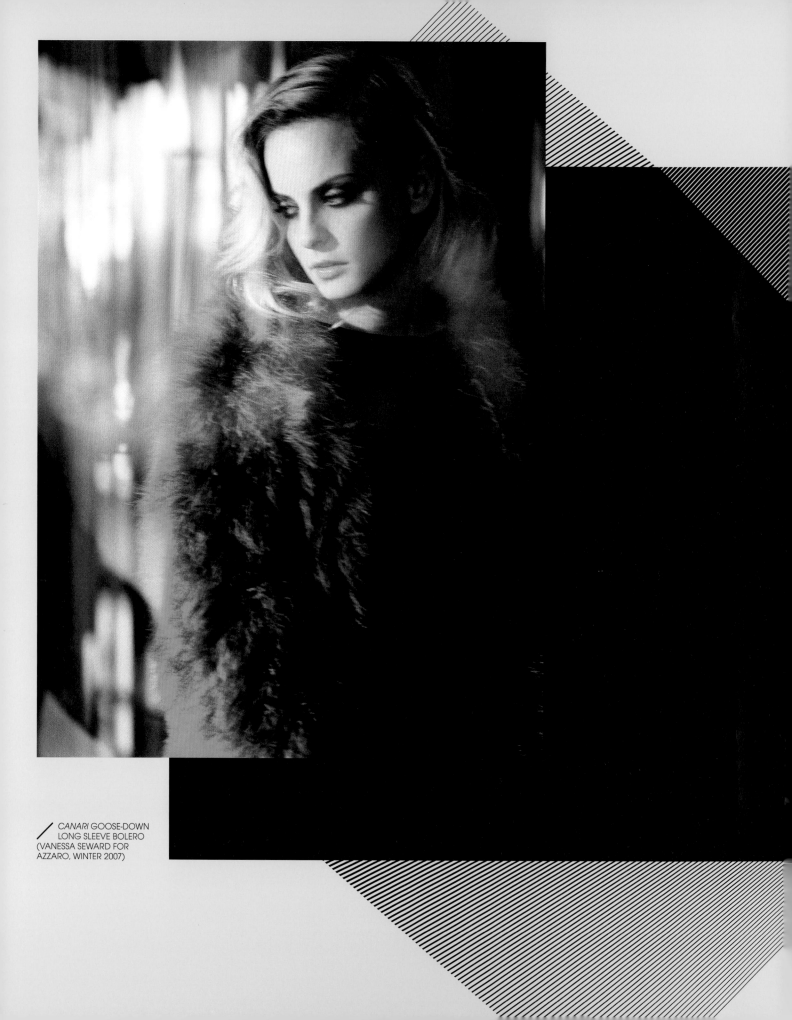

CANARI GOOSE-DOWN
LONG SLEEVE BOLERO
(VANESSA SEWARD FOR
AZZARO, WINTER 2007)

CONTENTS

HIS

INSPIRATION

THE SUN,
THE MEDITERRANEAN
AND THE ART

/ LORIS AZZARO
CIRCA 1977.

Tunisia, the sun and the Mediterranean are just a few of the inspirations for the goddess gowns designed by Loris Azzaro, along with the 1930s, films, Renaissance painting, the music of Mozart and a passion for Italian opera inherited from his father. As with any work of art, the cut of a dress, the elegant drape of the fabric and the sculpting of the material arose from an exhibition he saw or something he read, a conversation, a sky, an encounter, a memory... A whole host of emotions that the couturier shared with his muses—Marisa Berenson, Sophia Loren, Dalida, Joséphine Baker...—and his associates—his wife Michelle, his daughters Béatrice and Catherine, his *premières mains* or head seamstresses, Reinhard Luthier, his loyal friend Jean-Paul Solal—and that he left as a legacy to his grandchildren Romain, Laura, Roxane and Loris, whom he would unfortunately never know. And then, of course, there was a stream of stars, the likes of Marisa Berenson, Sophia Loren, Dalida and Josephine Baker.

Birth and childhood often herald the future. That was the case for Loris Azzaro, born in Tunis in 1933 to a modest but loving family. His Italian mother was born in San Gimignano, Tuscany, and his father on the island of Favignana off the coast of Sicily. This dark-haired, Mediterranean couple living in Tunis would give birth to a little blonde-haired, blue-eyed boy. "I often say that I am French by culture, an Italian of Sicilian origin who loves Venice, and an Arab at heart," he said, defining himself as "an Oriental born in Tunisia who appreciates French culture and taste."

Italy, Sicily, Venice, Greece, Tunisia, and later Djerba would remain his favorite places until the end of his life. Places imbued with everything he loved and then transposed to the dresses designed for evening and its mysteries—the light, the sun, the caressing breeze, the scent of citrus and flowers later conveyed in his fragrances, the color and warmth of the sand, and of course the sea that inspired his short cocktail dresses with that elegant Italian touch. This blue was in fact his favorite color, the very same color as his eyes, turquoise dresses, and djellabas in the hues of Yves Klein. His entire life was steeped in this blend of Mediterranean cultures, of Roman, Egyptian, and pre-Oriental civilizations, that he would mix together as if preparing a fine dish and add the ingredients of his own inner music to create something highly personal.

One of the greatest encounters of Loris Azzaro's life was Jean-Paul Solal, who was nine years his younger and would remain a close confidant throughout the couturier's life. Their friendship was known, but discreet. Solal never participated in a show, save once in Acapulco, or in the creation of a collection, although he was often present for fittings in the boutique.

"We were neighbors in Tunis," Solal explains. "He was extravagant, very sociable, very well-liked, and stunningly beautiful. He was solar, generous, dependable, complex and simple at the same time, and he could find a solution to any problem. He was incapable of hiding what he thought and was extremely inventive and imaginative. It was hard not to love him. Nothing holds much meaning anymore

without him... Michelle was more of a risk-taker, more ambitious. She was an unusual and reserved woman, but incredibly generous. They were the star couple of Tunis."

Loris Azzaro first saw Michelle in the streets of Toulouse in 1957, when he was studying French and Italian. A young woman from a bourgeois family, she was intrigued by his black cape coat, and the mystery and charisma he exuded. He was captivated by the beauty of this brunette with wide cat's eyes. It was love at first sight. They were introduced at a party by a common friend. She was 20, he was 24. They were married and remained so for the rest of their lives, despite the tough start, the rise to success, the life-changing encounters and other affairs of the heart. "And yet they were a true couple," Béatrice Azzaro confirms. "They were extremely complementary."

In 1958, they moved back to Tunis and a daily course of life in the sun. His diploma in hand, Loris taught French and Italian at the Lycée Carnot in Tunis. Michelle worked various odd jobs and also did a little modeling. A year later in February, Béatrice was born. Life was peaceful, albeit slightly routine, and Loris devoted his evenings to his love of sewing. Already as a teenager, he worked after school on his first designs for costume balls.

"My Sicilian grandmother had a machine and knew the basics of sewing," he recounted. "Since I didn't have a lot of money, I would go to the souk to buy fabric by the pound, and I made my own shorts, bathing suits and shirts with my grandmother's help. I learned how to sew at a very young age. Fabrics were the joy of my childhood; I was mesmerized by their colors and the way they caught the light in the souks. I wonder if this shimmering is not what inspired my fashion."

Aware of her husband's talent, Michelle convinced him to return to France. The couple moved to Paris in 1962 and got by as best as they could in a small apartment on Rue de Spontini in the 16th arrondissement. They were lean times in the beginning, living the kind of poignant bohemian lifestyle from which you are anxious

to move on and later look back upon with nostalgia. Loris sold vacuum cleaners door-to-door. Michelle worked as a model for Stevens, a brand of ready-to-wear headed by Jacques Esterel and Louis Féraud. "When the day went well, he gave her a gold coin," shares Béatrice, a tradition that prefigured the first jewelry gowns. They moved again several months later to 45 Rue de Sèvres in the 6th arrondissement where Loris began designing bags and belts. This is also where he designed the first piece of Azzaro jewelry, created for Michelle who dreamed of a Chanel necklace. It was displayed at the Carita sisters' salon and appealed to them so much, they commissioned three dresses for their boutique. "I get my inspiration piece by piece," he said. "I've had an idea come to me at two in the morning, perhaps in a dream, and I wake up with a start to make a sketch."

BOHEMIAN BLING

1966 brought a new encounter, Reinhard Luthier from Germany. Raised by an aunt enamored with haute couture, the young man left his native town at the age of 20 and went to live in Cannes. Invited by a friend of the family who owned a château on the Riviera that had become a hotspot for the international jet set, he hobnobbed with the biggest celebrities on the Côte d'Azur at the time: the Marquise de Cuevas, Florence Gould, international stars Margot Fonteyn and Rudolf Nureyev, couturiers Geneviève Fath and Hubert de Givenchy, who got him hired at Christian Dior in 1965 with a simple phone call. And then Loris Azzaro, whom he met at the Cannes Festival. There was an instant connection. Azzaro introduced him to Michelle, and the connection was just as strong. There followed seven years of vibrant and prolific collaboration, from 1966 to 1973. The three friends opened an initial atelier at 8 Rue de la Chaussée d'Antin with two seamstresses and Danielle Wick, an Irish embroidery artist who also became a model for the couture house. "We worked in 18 square meters," remembers Reinhard Luthier. "We started out with next to nothing. We used Michelle for our fittings. It was fun and the atmosphere was highly charged." Even so, the customers did not let the

four flights of stairs deter them from snatching up the crocheted and sequined jackets, Lurex dresses, boleros, beaded belts, fashion accessories and custom-made dresses worn by Michelle, who unwittingly became her husband's best ambassador.

Six months later, the threesome bought a neighboring apartment and inaugurated their first sales location in 1967, a booth squeezed between two shop windows in the Passage du Lido on the Champs-Elysées. Manager of Dorothée, one of the top ready-to-wear boutiques at the time (later to become Dorothée Bis), Jacqueline Jacobsen fell under the spell of these designs that captured the electric energy of the time. She placed a first order, and it flew off the racks. Another prominent contributor to the rise of the brand was Madame Samson, owner of the Light boutique on the Champs-Elysées. She too was not immune to the charms of the chic and sexy outfits, which she sold, initially at cut-price, in her many Parisian boutiques, such as La Machinerie and JNS 3, to name but two. "There were other major encounters," remembers Jean-Paul Solal, "such as Valérie Lamy, the empress of scarves, and the head of La Bagagerie leather goods." The brand would sell their famous black ribbon purse, costume jewelry, and wood-beaded bags and belts. Appreciative, Michelle Azzaro did not hesitate to say that the money they earned then paved the way for the couture house's success. Change of direction in 1968. The atelier moved once again, this time to 34 Rue Godot-de-Mauroy in the Madeleine district, and the collections were presented in the salons of the Hilton in Paris. The brand blazed a trail of glory with new stars. In Paris, Loris Azzaro dressed Dalida and said of her: "nothing is difficult with her,

FROM LEFT TO RIGHT: JEAN-PAUL SOLAL, ACTRESS MARISA BERENSON AND LORIS AZZARO IN SAINT TROPEZ IN 1975.

LORIS AZZARO AND ACTRESS MICHÈLE MORGAN, PRESIDENT OF THE JURY AT THE 1971 CANNES FILM FESTIVAL, AT A FITTING IN THE BOUTIQUE IN THE RUE DU FAUBOURG SAINT HONORÉ, PARIS.

she can wear anything." The singer often arrived incognito, wearing a jogging suit and knit cap, hoping to be left alone. "But as soon as she let down her hair and put on her dresses and shoes, she became Dalida," recalls Reinhard Luthier. She was buried in her *Raquel* jersey dress.

"Marisa Berenson is someone who contributed enormously to the launch and success of the house by posing for a number of editorial and advertising campaigns," confirms Reinhard Luthier, "and especially by bringing her friends Christina Onassis, Liza Minnelli who chose the *Gilda* dress for the film *Cabaret* herself, and Michèle Morgan who wore nothing but Azzaro when she served as president of the Cannes Film Festival in May 1971."

A new 100 m² apartment on Avenue Mozart, a leased Rolls Royce—it was all about show in those days. 1969, in the midst of the student protests, a new boutique was inaugurated in Rome on the via Borgognona, another the following year in Saint-Tropez with none other than Brigitte Bardot as a customer, and the boutique at 65 Rue

du Faubourg Saint-Honoré in November 1970. "His name is firmly rooted in the 1970s and 80s," affirms Olivier Saillard. "His style is extremely identifiable, for its festive and glamorous vibe, for its evocation of the feverish, sparkling world of nightlife."

"Those were marvelous years," recalls Reinhard Luthier. "We worked a lot and went out a lot. We attended Eddie Barclay's weddings, the Persepolis galas, Gunter Sachs' parties, the vampire ball for which we dressed Madame Gloria Guinness in a fully transparent organza dress. All of the women at all of these events were wearing Azzaro. We sold our designs around the world and held an annual runway show with jeweler Harry Winston at the Palace Hotel in St. Moritz. We vacationed in Saint-Tropez, but also in Sidi Bou Said, near Tunis. It was the Dolce Vita."

HE MADE EVERYTHING ART...

In addition to the Mediterranean, the 1930s, the films of Marilyn Monroe and Marlene Dietrich, the theater... the inspiration for these sculptural dresses was also fueled by the couturier's daughters, Béatrice, born in 1959, now a practicing psychologist, and Catherine, a stylist, born in 1968. Two women with strong temperaments and unique backgrounds who were involved in the life of the couture house at an early age by posing in their father's dresses.

Still today, Béatrice Azzaro has fond memories of the nightly 6 p.m. fittings at 65 Rue du Faubourg Saint-Honoré with her father, her mother, and the head seamstresses, where she watched, commented, and participated in the creation in her own way. "When he ate out at a restaurant, my father would arrange the food on his plate in a certain way and transform his meal into a work of art. He made everything art."

"I don't really get the feeling I'm a designer," he said. "I feel more like an artist. I'm drawn to all of the arts... Deep down, I'm a little neighborhood dressmaker. I'm having way too much fun to be a designer."

After graduating from high school, Béatrice Azzaro signed as a model with the Glamour agency. She went out dancing every night at Bus Palladium, one of the trendy Paris nightclubs, clad in sexy dresses and running shoes, setting an instant trend with hundreds of young women. But she was also interested in creation and, with her mother's guidance, designed the *Loris Azzaro lingerie* line, followed by *Azzaro B*. "I dreamed of studying philosophy instead," she says, "and then went on to work in radio. I wanted to make a statement with my words and not my appearance." From 1995 to 2002, she moved to Turin to get a little distance from Paris and also manage the Loris Azzaro bridal franchise.

"There was a very Italian atmosphere at home," she recalls. "Lots of loud talking, yelling, hugging. It would be the dead calm and then, two seconds later, the storm. I'd always had a very intense but complicated relationship with my father, and we renewed ties in 2002 when I moved back to France. I was with him right until the end. But I was admittedly much closer with my mother. We often went on holiday together. She was beautiful, ambitious, motivated solely by her work. We called her Napoleon. She was like a wild cat— an iron fist in a velvet glove."

A GOWN IN THE COLOR OF THE SOUL...

Edwige Feuillère was another influential muse. "For her farewell performance, he dressed her in a gown in the color of the soul," remembers Jean-Paul Solal. "Then Raquel Welch and especially Sophia Loren became close with the family. He styled her for a Red Cross gala and also designed a dress for her, now exhibited at the Tussauds wax museum in London. "She often came to our house for dinner," recalls Béatrice Azzaro. "She loved playing Scrabble. I was captivated by her beauty, her charisma, her intelligence, her sense of humor and her generosity. She even pretended to be the salesperson for a customer in the boutique who must have thought she was her doppelganger."

"One day, when I was 12, I came home from a photo shoot and found myself face to face with Sophia Loren in the living room," tells Catherine Azzaro, who was modeling for Elite at the time. "'Look how beautiful my daughter is,' my father said. 'She's taller than you.' Offended, she raised herself up on her tiptoes... Dad was gentle and protective, authoritative but fair. He was a model of honesty, good manners and culture. He was an excellent father, as warm and loving as only Italians can be. He was joyful and easy to live with. His mother lived with us back then, and they spoke to one another in Italian. Mom was a different matter. She was a businesswoman. She was not as easy-going, more reserved, she ruled our lives. Her work came before everything else. She was the one who built the couture house. None of it would have existed without her."

Another regular at Rue du Faubourg Saint-Honoré was Michèle Mercier, to whom Catherine would recite lines from her starring role in the film *Angélique, Marquise des Anges*. Or the opera singer Teresa Berganza, whose arias Loris loved to sing. "She often came to our house to perform," remembers Catherine Azzaro. "We had two pianos in the living room, and my dad liked to host small, intimate concerts."

They enjoyed frequent and extravagant entertaining in their home, and traveled extensively for major social events like the Rose Ball in Monte Carlo, the Formula One Grand Prix and the Rio Carnival. "This plurality of cultures and languages I was raised in is most likely what spawned my love of travel," he said, "my curiosity about other countries, my ease of communication with people. I owe a lot to my cosmopolitan adolescence." Although she was not as keen on these festivities, Béatrice accompanied her father everywhere. He on the other hand adored the big soirées, all the glitter and glam. "He captured the light," she continues. "He had an incredible presence, he was comfortable anywhere. He brought a wonderfully dramatic flair to our lives. He was also very possessive and hated when things got away from him. He was always very positive, always very active. He was fantastic and exhausting."

RAVEL'S *BOLÉRO*

Music had always been a big part of Loris Azzaro, who played the piano his entire life and loved to perform the Chopin Nocturnes, the Gymnopédies by Erik Satie and above all Mozart's sonatas. "I wake up to music," he said. "I fall asleep to music, I listen to music when I am alone, when I work." It was so important to him that he enrolled his 6-year-old grandson Romain, Béatrice's son, in the piano conservatory by the Parc Monceau in Paris. Six years of music theory, not necessarily idyllic, but that paid off since the boy, to whom Loris was passionately devoted, is now a music composer. The first piece he heard was Ravel's *Boléro*, which remains a vivid memory. There is a photograph of Romain as a baby wearing headphones. Another special memory of *Boléro* was in Saint Martin, during a shoot for the launch of the fragrance *Chrome*. A moment of bonding shared in silence. "He had a sense of humor," Romain recalls. "He loved slips of the tongue and causing little scenes. I often told him he was overdoing it, which was true and false, since he could be incredibly down-to-earth at times. On Sundays he played cards. He liked to cook. He walked me to school. He passed on his love of perfume, cuisine and art, but also the importance of good manners, kindness and courtesy."

Romain's sister Laura, now carving out a career in design, was closest with her grandmother Michelle, and inherited a lot of her character. The two women had lunch together every Saturday and went shopping on Rue du Faubourg Saint-Honoré and Avenue Montaigne, but also at Zara and H&M. "Grandma told me everything," she confides. "But always with a great deal of modesty. She was crazy about her husband, who was devoted to her with equal passion. I also have wonderful memories of Djerba, Sardinia and the country house in Vimory, not to mention grandpa, Romain and I photographed in the water during a trip to Saint Martin. I also have a slew of memories from the boutique, where I watched him dress stars and models,

but also moments with Dominique Salmon and Marie, the head seamstress who lent me a wooden mannequin to practice draping fabrics. I loved trying on all the stilettos, especially the 6-inch *Madonna* heels."

FROM STAR-STUDDED PARIS TO PEACEFUL DJERBA

Loris Azzaro designed dresses the way he decorated his homes, with an attention to detail and glamour derived from his roots, his love of beauty and his party spirit. "When I design a dress for a woman, I think of it as architecture," he explained. "I study her strengths and weaknesses. I highlight her qualities and conceal her flaws. The challenge is to make her as beautiful as possible."
Builder of silhouettes, Loris Azzaro was also a builder of homes, for he loved interior decoration. He had an infallible knack for scouting out apartments that he would renovate completely, decorate in an opulent style and then resell. It was the perfect way to keep his spirits high and stave off routine. "My home is a vital luxury," he said. "To feel good, I need to be in a shell where nothing disturbs the eye, and the shapes and colors are aligned with my tastes. I like mixing styles any which way, as long as it's pleasant. A house without decorative objects is like a house without friends."
The 1980s were the golden years. The family had a string of luxury cars, and moved every four years. Since 1977, they had been living in the 1,500 m² apartment on Boulevard Maunoury featured in *Vogue* magazine. With the help of interior designer Alberto Pinto, it was decorated with sprawling leather couches, Steinway pianos, symbolic decorative objects like Maria Callas' lectern, and the Kees van Dongen painting "Woman in a Blue Coat", his favorite color. Then there was the 750 m²-apartment on Avenue Foch, adorned with paintings by André Lanskoy. "We lived in extraordinary Hollywood-esque apartments," recalls Catherine Azzaro. "Decorating was his favorite pastime, and I inherited his passion. He always had a pair of work boots in the trunk of his car. I was told

that when he was young and living in Tunis, he loved taking apart a huge crystal chandelier to clean it and put it all back together again. Everything began with a whim, a little trick or a surprise. He loved creating secret passageways, inserting disappearing screens into the ceilings, designing monumental marble bathrooms with mirror-lined walls."

"I remember my grandfather's marvelous apartments and their fairytale magic," describes Roxane, Catherine's eldest daughter who after having done an internship at the couture house in Paris now lives in Sardinia where she manages the restaurant Giagono. Her brother Loris, born after the couturier's death, was scouted in Los Angeles to play in a Batman film. The years go by, but the family remains as driven as ever by their shared passion for Epicureanism, creativity and art. As someone who loved the high life as much as he enjoyed the simple pleasures, Loris Azzaro sojourned regularly in Djerba to delve back into his past, "the pastries my mother baked and the dresses my grandmother sewed. That is essentially what I've been doing all my life, cakes and dresses." But most of all he went to restore his inner peace and to escape the bustling life of Paris with its social obligations and other inessentials.

"I'm filled with nostalgia for Tunisia because that is where my roots are," he said. "And when I arrive in Tunisia, I make like the Pope, meaning I get down on one knee and I kiss the ground because it is the land of my odors, my colors and my flavors. It's where I feel truly at home."

He loved living in Djerba "because everything is simple there, everything is easy." He had a house built there for the birth of his grandson Romain, and it soon became his fief. "He drew the plans himself," explains Catherine Azzaro. "A white construction in the Djerbian style, looking out over the sea. It has also been featured in a number of magazines. San Pantaleo in Sardinia, however, was my mother's haven, where I spent all my holidays. I've lived there since my father died. He'd only been there twice, once in 1985, and again in 1993 for my wedding."

In Djerba, the couturier worked on his tan, wore a djellaba to the souk, reunited with the tastes and smells of his childhood, and met with his friends to play cards on the terrace of the Ben Damech café. "Here we live disconnected from daily preoccupations," he said, "with no technology or telephones."

"We stayed in this beautiful white house with next to nothing," remembers Jean-Paul Solal. "It was the complete opposite of Paris. Loris lived in three pairs of old shorts and four t-shirts. Most of the time he went barefoot. He loved getting back to his roots."

On the soothing shores of this island, he cultivated his passion for the scents later found in some of his olfactory creations, like *Azzaro 9* for example, a bouquet of jasmine named after his date of birth, 9 February 1933.

/ **TOP, LEFT:** LORIS AZZARO
AND GIRLFRIEND
IN TOULOUSE, CIRCA 1953.

/ **BOTTOM, RIGHT:**
LORIS AZZARO
WITH A FRIEND IN TOULOUSE,
CIRCA 1953.

LORIS AZZARO AND
MICHELLE, CIRCA 1954.

/ **ABOVE:** LORIS AZZARO
AT THE WHEEL OF HIS
MUSTANG IN 1967.

/ **RIGHT:** LORIS AND
MICHELLE AZZARO,
WEARING HER *TROIS ANNEAUX*
DRESS, IN THE PORT OF SAINT
TROPEZ CIRCA 1972.

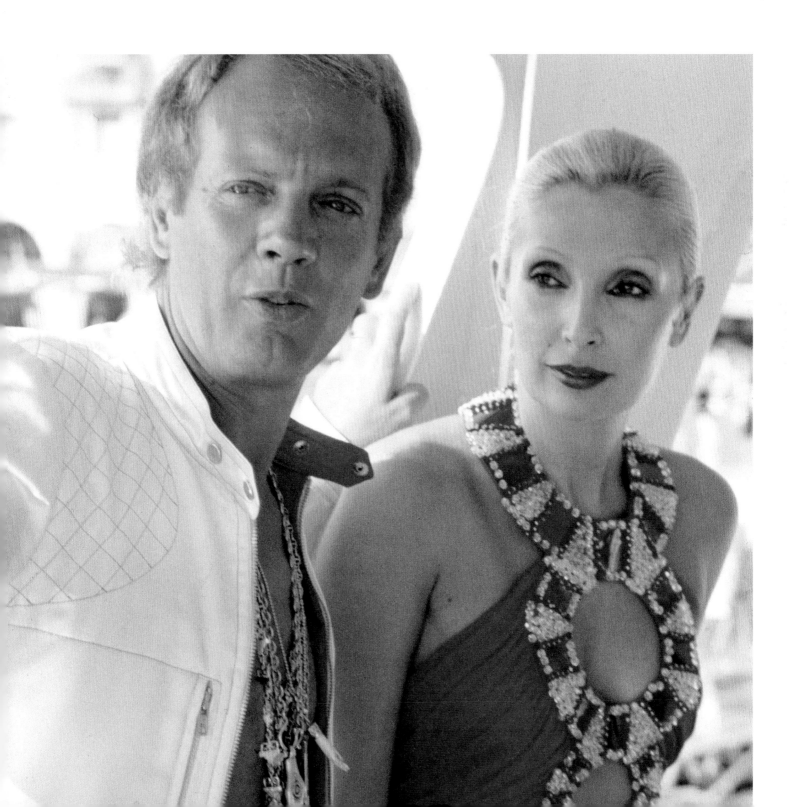

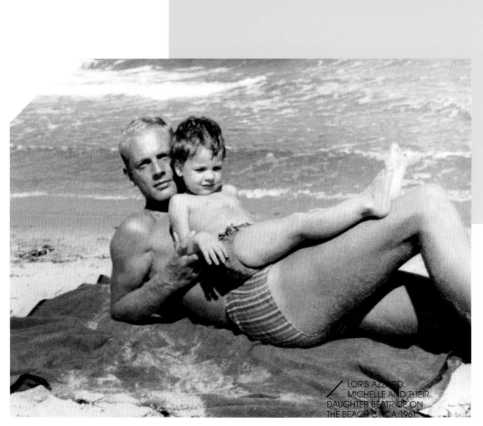

LORIS AZZARO,
MICHELLE AND THEIR
DAUGHTER BÉATRICE ON
THE BEACH CIRCA 1961.

RIGHT: MICHELLE AZZARO
IN AN OFF-THE-SHOULDER
CALAIS LACE SHEATH DRESS
WITH FLOUNCE DETAIL.

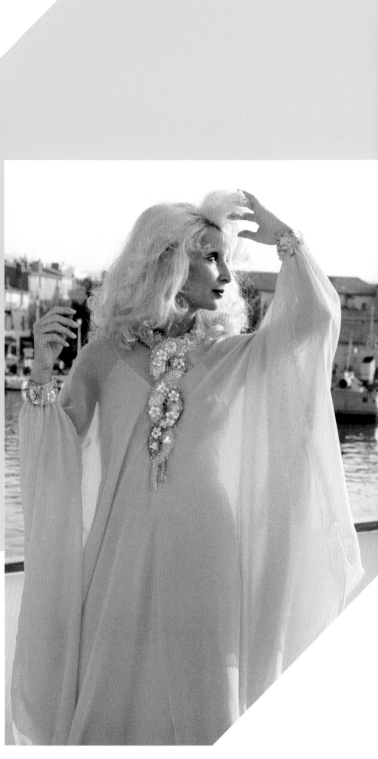

/ MICHELLE AZZARO
IN SAINT TROPEZ,
WEARING A SILK CHIFFON
TENT DRESS WITH FLOWER-
EMBROIDERED NECK
AND CUFFS.

/ **TOP:** MICHELLE AZZARO
WEARING A JERSEY
SHEATH DRESS WITH CUTAWAY
SLEEVES EMBROIDERED WITH
ORGANZA FLOUNCES.

/ **ABOVE:** LORIS AZZARO IN
SAINT TROPEZ CIRCA 1972.

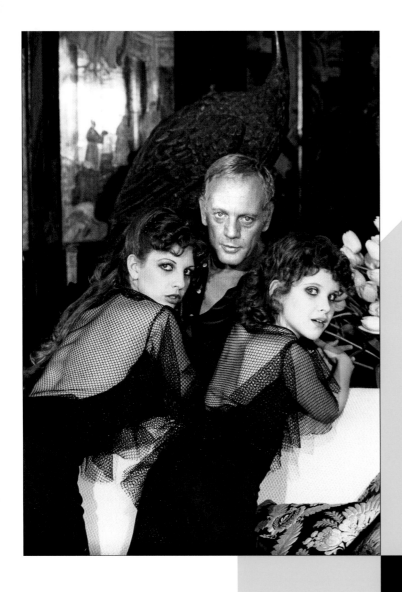

/ **ABOVE:** LORIS AZZARO
PICTURED WITH HIS TWO
DAUGHTERS IN 1977 IN HIS
AVENUE DU MARÉCHAL
MAUNOURY APARTMENT, PARIS:
ON THE LEFT, NINETEEN-YEAR-
OLD BEATRICE; ON THE RIGHT,
NINE-YEAR-OLD CATHERINE.

/ **RIGHT:** LORIS AZZARO
PICTURED IN 1975 IN THE
LIVING ROOM OF HIS AVENUE
DU MARÉCHAL MAUNOURY
APARTMENT, RECLINING ON
A PILE OF DAVID RUCLI LAME
CUSHIONS.

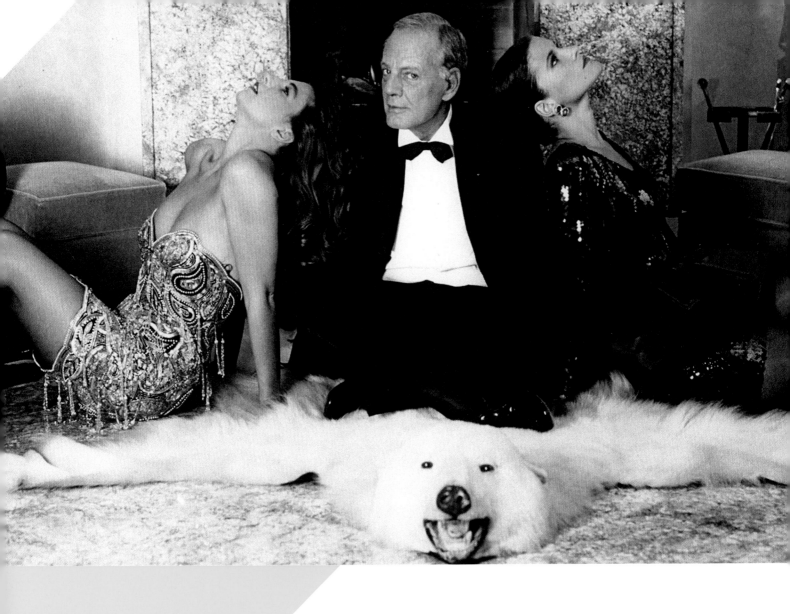

/ LORIS AZZARO PICTURED
 WITH HIS TWO DAUGHTERS
CIRCA 1988 IN HIS BOULEVARD
SUCHET APARTMENT, PARIS.
ON THE LEFT, BEATRICE
WEARS A SHORT SHEATH
DRESS FEATURING HAND-
EMBROIDERED PAISLEY MOTIFS,
POMPOMS AND PEARL BEADS.
ON THE RIGHT, CATHERINE
WEARS A SEQUINED SHEATH
DRESS WITH TAFFETA OVERLAY
AND RUCHED WAISTLINE.

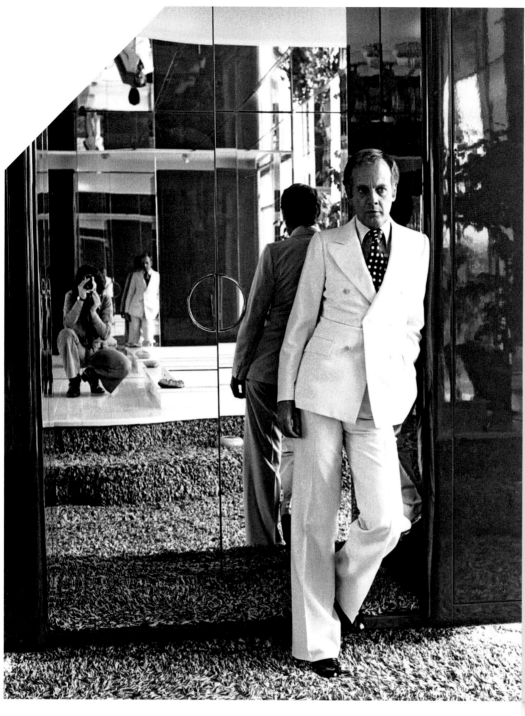

/ ABOVE AND RIGHT-
HAND PAGE: LORIS
AZZARO CIRCA 1977 IN
HIS AVENUE DU MARÉCHAL
MAUNOURY APARTMENT
FEATURING INTERIOR DESIGN
BY ALBERTO PINTO.

/ RIGHT: LORIS AZZARO
PICTURED IN THE
AVENUE FOCH APARTMENT
WITH THREE OF HIS MODELS
WEARING THE DRESSES HE
DESIGNED FOR SOPHIA LOREN
(LEFT), CLAUDIA CARDINALE
(CENTER) AND RAQUEL WELCH
(RIGHT). PHOTOGRAPHED IN
1985 BY THE GUARDIAN ON THE
OCCASION OF INTERNATIONAL
WOMEN'S DAY 1985.

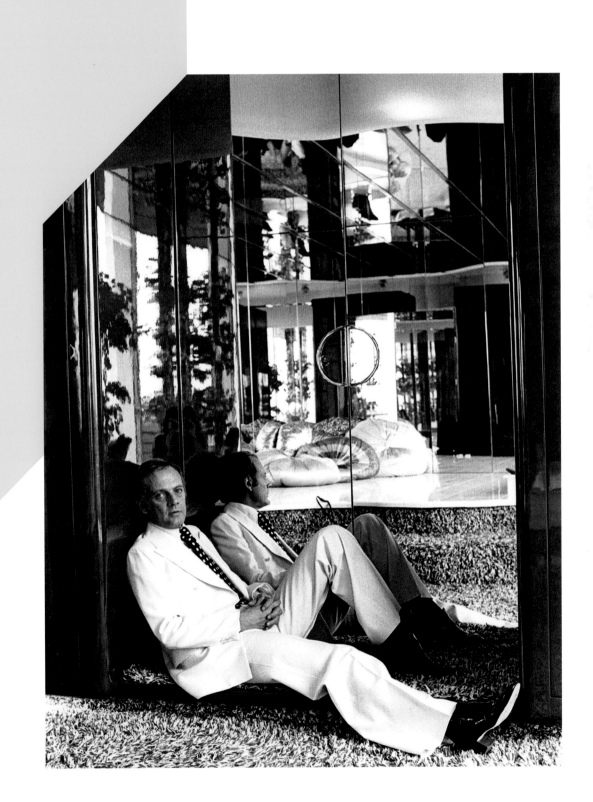

THE
AZZARO
STYLE

AN ODE TO GLAMOUR

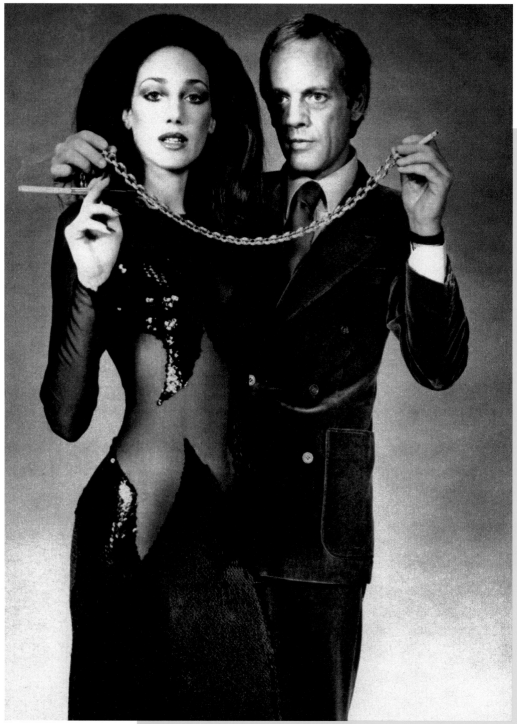

/ ACTRESS MARISA
 BERENSON AND LORIS
AZZARO PHOTOGRAPHED
IN 1973 FOR ISSUE 604 OF
*L'OFFICIEL DE LA COUTURE ET
DE LA MODE DE PARIS*. MARISA
WEARS A SEQUINED SHEATH
DRESS WITH SEE-THROUGH
FLAME MOTIFS ON A SILK
CHIFFON BACKGROUND.

Sculptural, sensual, inimitable—Loris Azzaro invented a style that is above all a story of silhouettes, lines and architectural construction that can be seen in the flowing dresses, elegant draping, shimmering lamé, shining sequins and reflections of light. An ode to glamour, femininity, soft and provocative sensuality, the Azzaro style is incarnated in evening dresses—or dresses for one evening—nymph-like shifts and goddess gowns designed for galas and nights at the opera, worn by the world's most beautiful women. Obviously, those who have lived and worked with Loris Azzaro are best placed to talk about his style. Béatrice and Catherine Azzaro, his daughters, Reinhard Luthier, his friend and associate during the glory years, and Vanessa Seward, who has succeeded in giving new impetus to the fashion house following the couturier's death in 2003. Rebellious, brilliant, creative, Loris Azzaro was a man well-loved, a lover of love and life, who dared to bare women as he dressed them to bring their true selves to light.

"He had the gift of exalting a woman's figure," explains Béatrice Azzaro, Loris's daughter, "enhancing the neckline, slimming the hips, accentuating the waist, with unwavering attention to beauty, comfort and elegance. He made every woman a femme fatale. And as much with taffeta gowns as with flowing bias-cut jersey designs, dresses with sparkles or sequins, dresses that fit like a second skin, all exquisite to wear and incredibly confidence boosting."

In 1965, he made a name for himself as the only one to design dresses that made every woman desirable, and one of the first to work with transparent material. Timeless and ever-stylish, cut from fabrics that are easy to work, none of his creations bowed to the whims of trends—something he defended his entire life. "Because fashion goes out of fashion," he said. "It is an unbearable dictatorship. I'm not interested in fashion. Above all I'm interested in women."

In the 1960s, the breath of revolution that swept through the arts made its way to the frills and flounces of couture. And these refreshing winds of rebellion came primarily from London with Mary Quant flaunting the first miniskirt designed by John Bates. In step with the times without being a slave to them, Loris Azzaro launched his line of evening dresses that broke with the prevailing aesthetic. "I always work with the same base," he said, "sexy, accentuated curves, sheerness, décolleté. Bare backs, but veiled. And never more than two fabrics so as not to interfere with the silhouette." The ultimate performance, the magician of vamp silhouettes created his little gems with the help of his two head seamstresses, Simone and Suzanne. His designs were immediately categorized as luxury ready-to-wear and not haute couture, for the house did not launch collections on a regular basis and was thus never recognized by the governing trade association, the Chambre Syndicale de la Couture Parisienne. An against-the-grain approach taken simply to avoid falling prey to routine, and one that earned him compliments from the competition. "You make the most beautiful bustiers and evening gowns in Paris," Yves Saint Laurent

once told him. Everything created in the first atelier on Rue de la Chaussée d'Antin—the jewel dresses, the chain dresses, the draped, flowing or more structured dresses, the sequined jersey jackets accoutered with glitter, rhinestones and beads, the jet-black resin, Lurex or silver boleros—was an instant hit. "Dresses made for women to put on and for men to take off," he said.

"Our creations were inspired by Greek and Roman mythology," explains stylist Reinhard Luthier, a key figure in the history of the Loris Azzaro house and who shared his life with the couple from 1966 to 1973. While Reinhard focused on the Lurex designs, Michelle, the wife who was also the founder of the house and later CEO, stuck to the more marketable cocktail dresses, while Loris saved himself the thrill of glamorous eveningwear. "What he wanted, what he loved, was to dress the boldness of the night," writes Jéromine Savignon in her book *Azzaro*, published by Assouline. "To make wildly distinctive dresses that would never be out of style— dresses that would take people's breath away and create an impact." All of these creations showcasing the art of bias cut and drape, with fabrics chosen by Michelle, had a whiff of brimstone and rebellion about them. "They were fantastic years," confirms Béatrice, "post-1968, the years of bisexuality, the era of peace and love, glamour and sweet excess. They were jovial and carefree years."

But in this ode to sensuality, parties and the night, stylistic contrasts also created a sensation, like the simple little white New Year's Eve dress that supermodel Cheryl Tiegs wore for the cover of *Elle* magazine on 16 December 1968. A low-cut brassiere trimmed with rings along with a short, flared skirt, the height of simplicity. It was a planetary success, followed by other milestones like the inauguration of a boutique in Rome on Via Borgognona that became the go-to for Italian high society. And since photography had become a leading medium of communication, on a par with art, photographers like Helmut Newton in the beginning, and later Guy Bourdin, jumped on the bandwagon and shot portraits of Brigitte Bardot, Jane Birkin, Angie Bowie, Marisa Berenson...

dressed in the femme-fatale creations imbued with all the gaiety, folly, joy and frivolity of the time. Since a couture house's coming of age is often marked by the creation of a fragrance, *Azzaro*, an eau de toilette with chypre notes, was launched in 1975. Three years later a new fragrance took the perfume world by storm with *Azzaro Pour Homme*, the iconic scent of masculine seduction. An aromatic woody fougère embodied "men who love women who love men", and quickly became the top-selling men's fragrance in Europe, Latin America, and above all Brazil. In the meantime, a boutique opened at 733 Madison Avenue in New York, and a line of eyewear and leather goods was also launched in 1977.

DRESSES SEWN *AND* CUT WHILE WORN

Among the designs that marked the history of the house are dresses that remain jaw-dropping to this day: the *Baba, Raquel,* and *Birkin* dresses, the *Domino* he made for Brigitte Bardot, and the *Trois Anneaux* that made a smash comeback when Carine Roitfeld, editor-in-chief of *Vogue* France, wore it to a party years later in 2003. His creative binges also included costumes for the stage and screen, notably for a Vittorio De Sica film and the Crazy Horse dancers, not to mention Liza Minnelli, who came to the boutique in person to choose the dress she wore in *Cabaret*. He also designed dance apparel for choreographer Carolyn Carlson and the costumes that singer Diane Dufresne wore in the rock opera *Starmania*. He dressed the Princess of Jordan, the Countess de Beaulieu, and the Duchess de La Rochefoucauld for the Niarchos daughter's wedding. For a special event, the couturier sewed a dress onto Marisa Berenson while she was wearing it. Elsa Schiaparelli's granddaughter came with only her hair and makeup done, and left in a zipperless, flesh-tone shift. Elizabeth Taylor was also a regular at Rue du Faubourg Saint-Honoré, as was Tina Turner whose dresses Loris and Reinhard cut out with scissors while she was wearing them, sending the customers into screams. After her concerts, the singer took them

out to the Chez Régine nightclub. He made a
fully embroidered sheath dress for Maria Callas
and, his crowning glory, dresses for Princess
Paola of Belgium that he had knitted by the
women who worked as ticket punchers in the
metro, given the urgency of the order. "Some of
my famous customers have become friends," he
said. "I owe them a lot, for they are the reason
I'm known today. We made a deal. I made them
beautiful and they made me famous."
And let's not forget Dalida, to whom the Palais
Galliera, the city of Paris fashion museum,
paid tribute in spring 2017 with an exhibition
presenting a dozen or so pieces from the singer's
on- and off-stage wardrobe. "Loris Azzaro's career was perfectly in
tune with the time," notes Olivier Saillard, the museum director,
"those provocative and sensual years. He quickly shot to fame
because photos of his creations were often featured in the pages of
the biggest fashion magazines."
His whole life through, Loris Azzaro shared this reverence for
women without idealizing them, this love of beauty, light and
mystery with those around him. In 1996, Dominique Salmon was
one of the remaining few. Today, she is still the heart and soul of the
boutique on Rue du Faubourg Saint-Honoré that she has managed
for over 20 years. "The house is celebrating its 50th anniversary,"
she announces with pride, "and the spirit of Monsieur is still there.
He was wildly charming and charismatic. He was impassioned
and fascinating. He was unique."
When Michelle Azzaro was looking for someone to manage the
ready-to-wear on the ground floor of the boutique, she hired
Dominique Salmon who then went on to become studio manager
and fit model, before moving up in rank—and up a floor—a few years
later, promoted to head of couture. "Michelle Azzaro had a very
strong personality," she remembers. "She was a remarkable woman

who oversaw and managed everything, as lavish with her caresses as she could be with her claws just seconds later. She was beautiful, brilliant, and complex. If the house is here today, it's because of her."

PERSIAN CATS, TROMPE-L'ŒIL GARDENS, MURANO CRYSTAL

In 2000, Loris Azzaro appointed his second daughter, Catherine, to the position of CEO. She was someone who knew the house well, since before becoming his valued colleague, she started out as his model, posing in his dresses for photographer Guy Bourdin on a commission for *Vogue*. "I was lucky to learn the trade from one of the greatest stylists of his time," she enthuses, "and meet the stream of stars who came to our house and to Rue du Faubourg Saint-Honoré." Fashion was an integral part of her childhood. She spent her free time with the women working in the ateliers. And since she was good with a pencil, she contributed to the designs at an early age. "I was born into the business and trained to take over the reins. But even more than his passion for the trade, Loris Azzaro taught me a great lesson in life by tiptoeing off the stage with grace and humility."
After her time in front of the camera, Catherine Azzaro became an assistant, fashion show organizer and stylist. "Working at his side was an extremely enriching experience," she confides, "as was watching him create. Our shows in Paris and abroad were exciting, exclusive, often private moments. We spent a lot of time together. They were wonderful years."
Some shows were organized with luxury jewelers like Van Cleef & Arpels and Boucheron in 1982. The after-party for this show was one of the most spectacular, captured like so many others in the pages of *Vogue* and *L'Officiel de la Couture*. "We threw the party in our apartment on avenue Foch where models wearing taffeta gowns and Alexandre de Paris feathers in their hair paraded around cradling Persian cats in their arms," recalls Catherine Azzaro. "Then there was a formal dinner, the tables laid with fish-shaped Murano crystal

glasses dusted with gold. Loris had created trompe-l'œil gardens and adorned the walls with shantung hangings. The crème-de-la-crème of Paris was there: princesses, actresses, political figures and a host of other celebrities."

In the glittery wake of this creative and social ferment came the openings of boutiques in New York, on Canyon Drive in Los Angeles, Saint-Tropez, Monte Carlo and Paris... Until the 2000s, the house continued to cultivate its world-renowned reputation for chic sensuality and glamour. Couture and fragrance contributed to its success and the family traveled the world to present collections and attend fragrance launches. "Azzaro was synonymous with sensuality and exalted beauty. The name was associated with movie stars and showbiz celebrities. You wore Azzaro to be noticed," insists Catherine Azzaro.

The style kept pace with the times in its own way and, even better, highlighted them without ever departing from its provocative, dreamy and playful origins. "The Azzaro woman is as sophisticated as ever," she continues. "She walks on stilettos from morning 'til night, with red lips and charcoal eyes." Catherine created, sketched her designs and organized fittings with her father and mother. A minimum of three fittings to perfect a prototype, sometimes ten if necessary. The most famous customers had a Stockman dummy made to their measurements.

"Behind the jewel dresses, the draping fabrics, the shifts and the lamés, he strove above all to invent a new idea of what it was to be a woman," analyzes Olivier Saillard, "and she latched onto the phenomenon readily, wearing his creations against her skin. Most of the dresses actually revealed some skin. They had a gentle, elegant and joyful provocation about them."

The creative process always began with the couturier sketching on paper with baffling skill. Three pencil strokes said it all. And three words, next to nothing, to Simone Palace, the pattern designer, who understood it with one glance and prepared the first canvas pattern for the next day. Six p.m., there was a joyful, studious,

intense and warm atmosphere. Monsieur smoked a lot. The cigarettes burned slowly. He pondered, blinked to gain a new perspective on the sketch, altered the length of a hem, adjusted a sleeve, changed the drape, laid out a pattern of sequins, submitted ideas, proposed, punctuated... All under the watchful eye of Michelle and Béatrice, and later Catherine, the three women in his life. "He put on his show," tells Catherine. "He played to the gallery, dressed up in costumes, made puns as he supervised the fittings. It was his hour of madness. Everyone loved him—the seamstresses, the sales staff, the customers. Everyone."

WITH COUTURE, WE'RE SELLING DREAMS...

"Loris Azzaro never made collections for the sake of making collections," explains Dominique Salmon. "He sketched anywhere, anytime. He was always at the boutique. While he may have owned several Rolls-Royces in his lifetime, he loved the simple joys of listening to Mozart full blast in his Smart car. He was an extremely knowledgeable, sophisticated and very well-balanced man who never forgot his humble beginnings. Nothing made him happier than to be with customers who shared the sentiment. He was the reason they came to us. Everything was done in-house. The atelier was above the boutique, and some of the seamstresses worked from home. It was a gentler, more human, more festive time. There was always a kind of folly in the air. The joy in Paris then was almost palpable."
A sensitive visionary with an insatiable curiosity, Loris Azzaro immediately knew what would work on any woman. "I was lucky to have styled the most beautiful women in the world and it was incredibly fun," he said. "Creating a dress for a woman who doesn't know just how beautiful she can be is absolutely enthralling."
He placed them all on the same pedestal and was just as thrilled to work with those who had saved up to buy the dress of their dreams, as he was to style a star or a princess. "He knew how to give breasts and a derriere to women without curves," confirms Jean-Paul Solal, who

remained a close friend to the couturier throughout his life. "He had the art of showing them in their best light. Brigitte Bardot once told him, 'I want a dress that lifts my spirits and my breasts.'"

The history of fashion is written with big names, but also with more discreet niche labels that paradoxically receive enormous support from an audience that is not necessarily interested in the subject. Something that Olivier Saillard confirms, adding that by "focusing on evening dresses, which worked well in his day, Loris Azzaro showed a pragmatism that is currently lacking in the world of couture. He was both a designer and a business owner, one of the last self-made men of his generation, an endangered species. Because today fashion is made to please fashion and not to please women."

The responsibility of safeguarding a style and above all a state of mind after the couturier's death fell to Vanessa Seward. The talented young stylist is pursuing the adventure with her own personal touch while staying true to the spirit of the couturier she has always deeply admired. In 2006, Maria Reig Moles, president of Reig Capital, bought the house and thus helped to perpetuate the Azzaro style and everything it stands for: sophisticated, glamorous, feminine and eminently Parisian couture, sold in a legendary boutique where the spirit of Loris and Michelle lives on. "Our house was, is and always will be a story of passion," proclaims Dominique Salmon. "Because with couture, we're selling dreams."

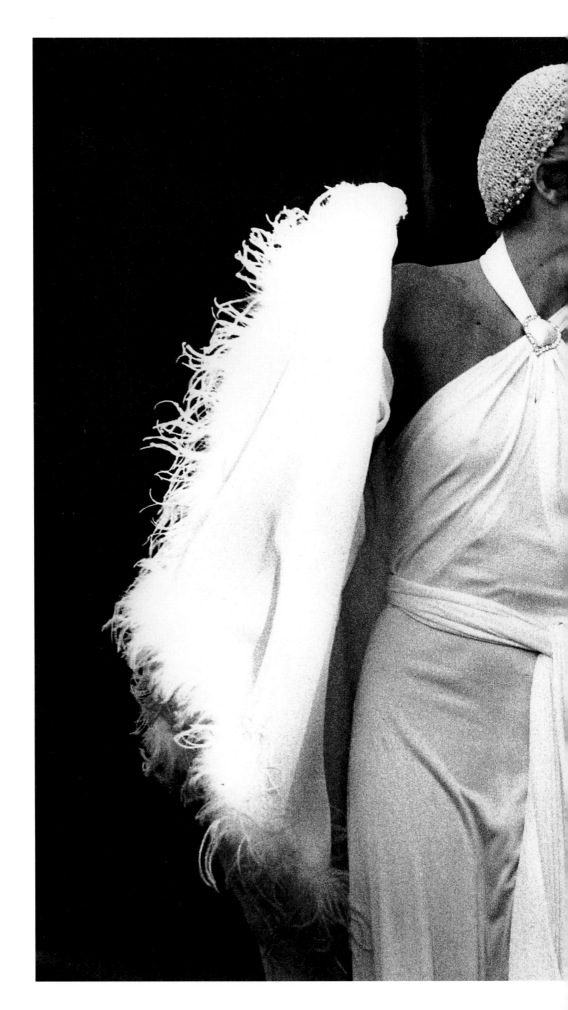

TWO DESIGNS PHOTOGRAPHED IN FEBRUARY 1973 FOR *VOGUE ITALIA*. LEFT: SILK JERSEY CREPE DRAPED OVER THE HIPS WITH NECKLACE DETAIL AND LONG FLOWING BELT. RIGHT: JERSEY CREPE DRESS WITH SIDE SLIT, SIDE-RUCHING AT ONE HIP AND SWEETHEART NECKLINE.

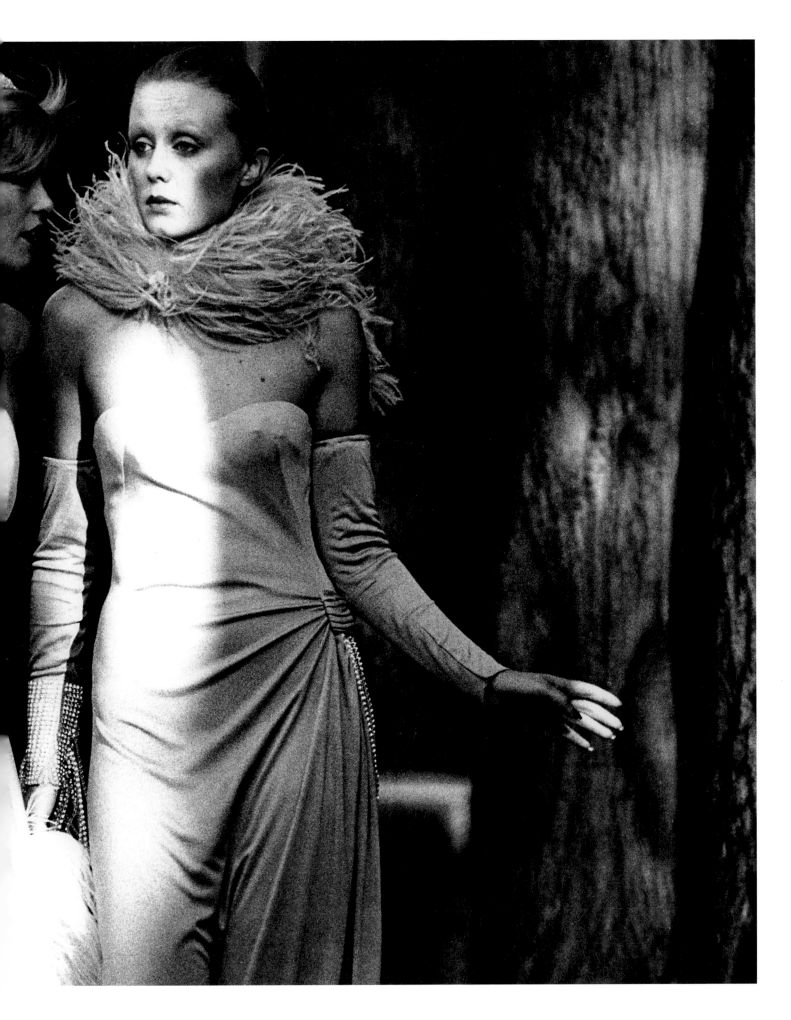

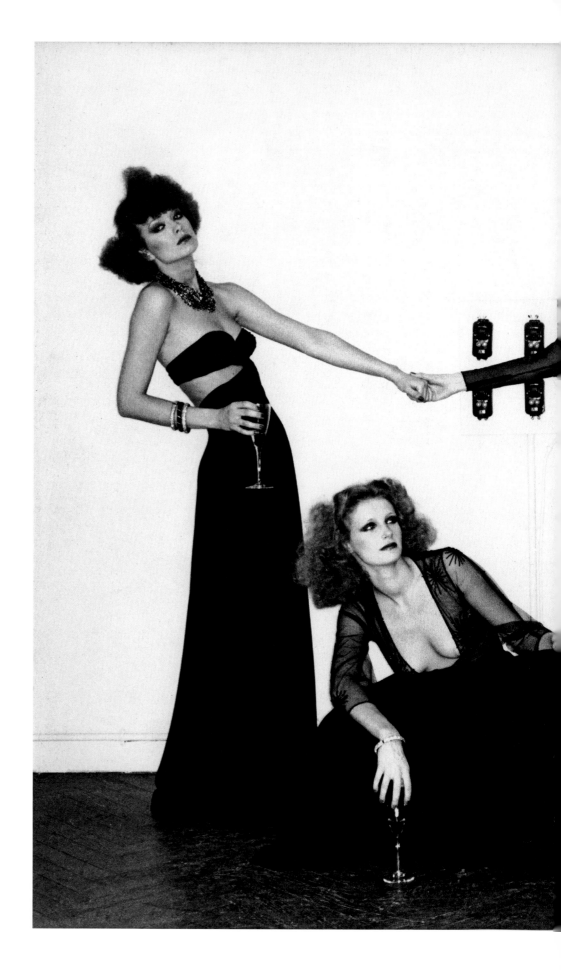

/ LORIS AZZARO AS
JAMES BOND WITH FOUR
OF HIS *GIRLS*. FROM LEFT TO
RIGHT: JERSEY SHEATH DRESS
WITH FLARED SKIRT AND DRAPE-
FRONT BRA; TRANSPARENT SILK
CHIFFON DRESS EMBROIDERED
WITH SILVER TUBE BEADS IN THE
FORM OF STARS; SEQUINED
SHEATH DRESS WITH SEE-
THROUGH FLAME MOTIFS ON
A SILK CHIFFON BACKGROUND;
JERSEY DRESS WITH SWAROVSKI
CRYSTALS.

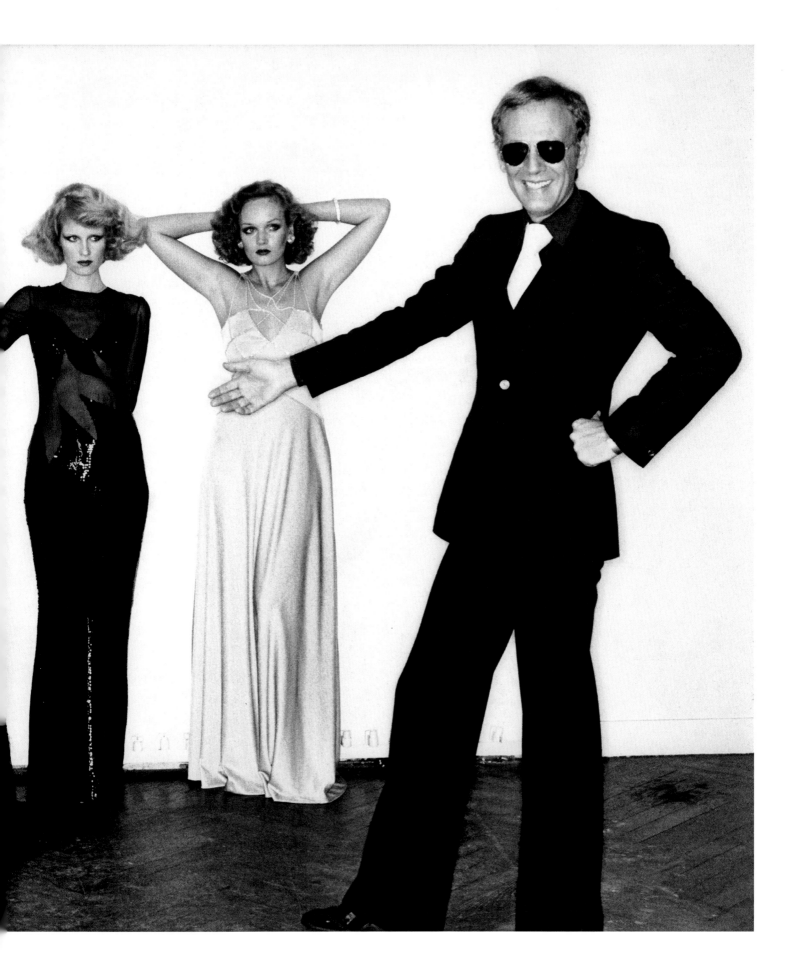

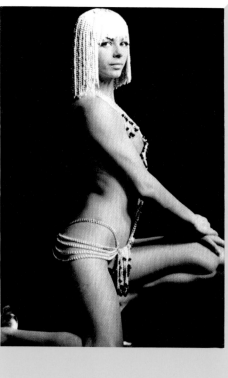

/ DANCER SOPHIA
PALLADIUM IN LUREX
STAGE COSTUME WITH CHAIN
WIG – A LOOK THAT BECAME
THE HALLMARK OF THE CRAZY
HORSE DANCERS IN 1969.

/ OPPOSITE PAGE:
ITALIAN SINGER RITA
PAVONE IN JERSEY GOWN,
POSING IN 1972 FOR *GRAZIA*
MAGAZINE IN FRONT OF A
POSTER FOR THE FILM *GILDA*.

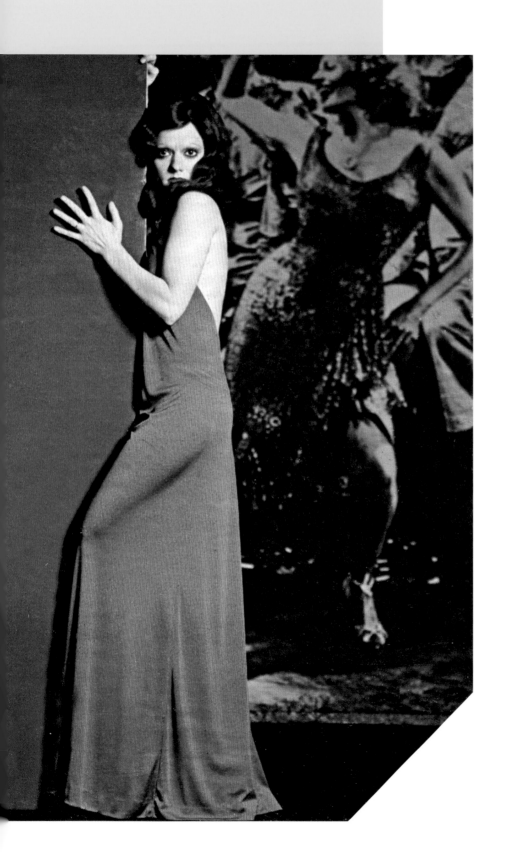

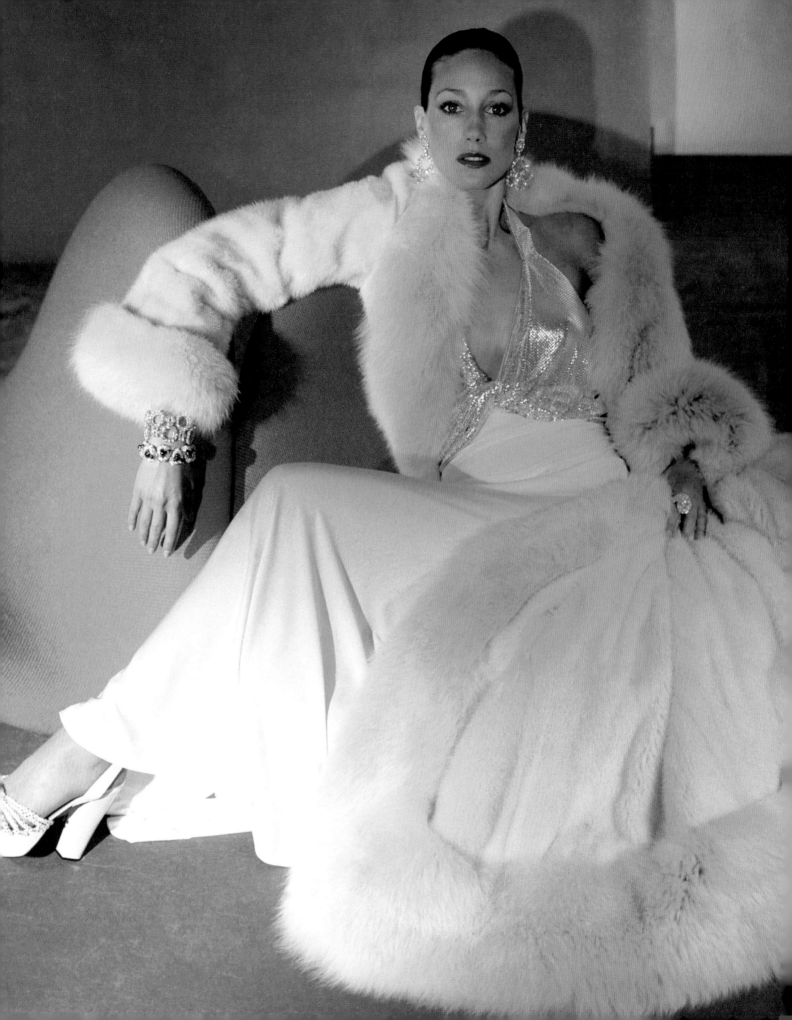

DRESSES MADE FOR WOMEN TO PUT ON AND FOR MEN TO TAKE OFF.

Loris Azzaro

/ ACTRESS
MARISA BERENSON
PHOTOGRAPHED IN 1972
FOR *VOGUE PARIS* WEARING
A FOX-TRIMMED SAGA MINK
COAT OVER A JERSEY *MERCURE*
DRESS WITH SLINKY METAL MESH
BUSTIER.

/ ACTRESS
MARISA BERENSON
PHOTOGRAPHED IN 1973 FOR
VOGUE PARIS, DRESSED IN A
SEQUIN-EMBROIDERED SILK
CHIFFON SHEATH GOWN –
A NOD TO MARLÈNE DIETRICH

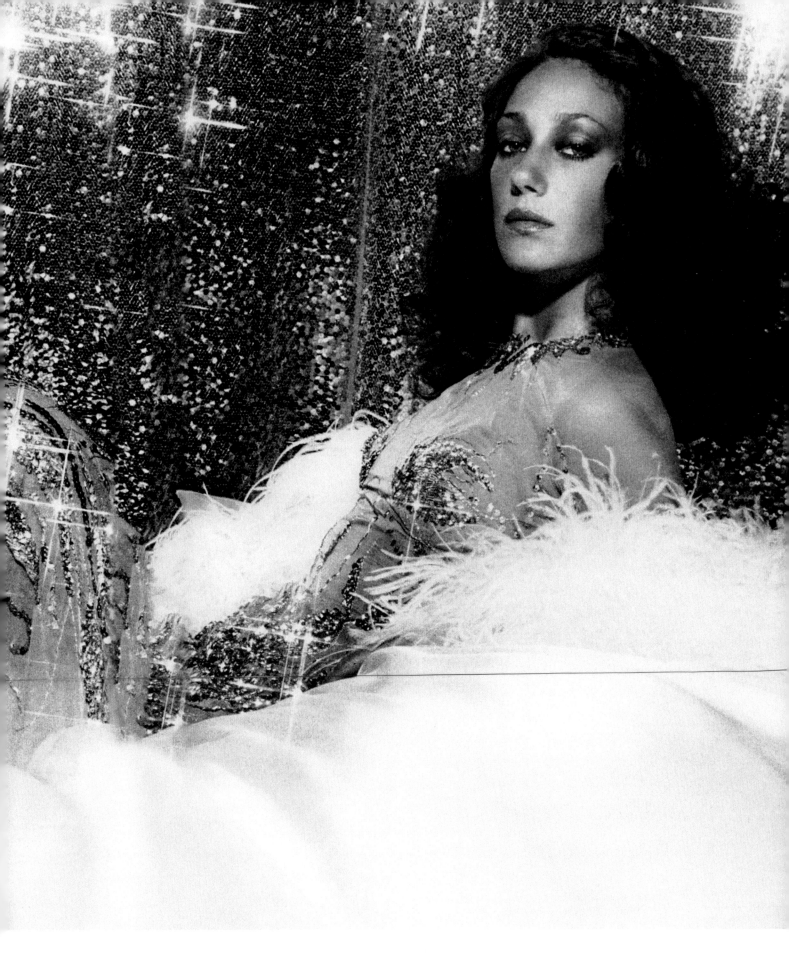

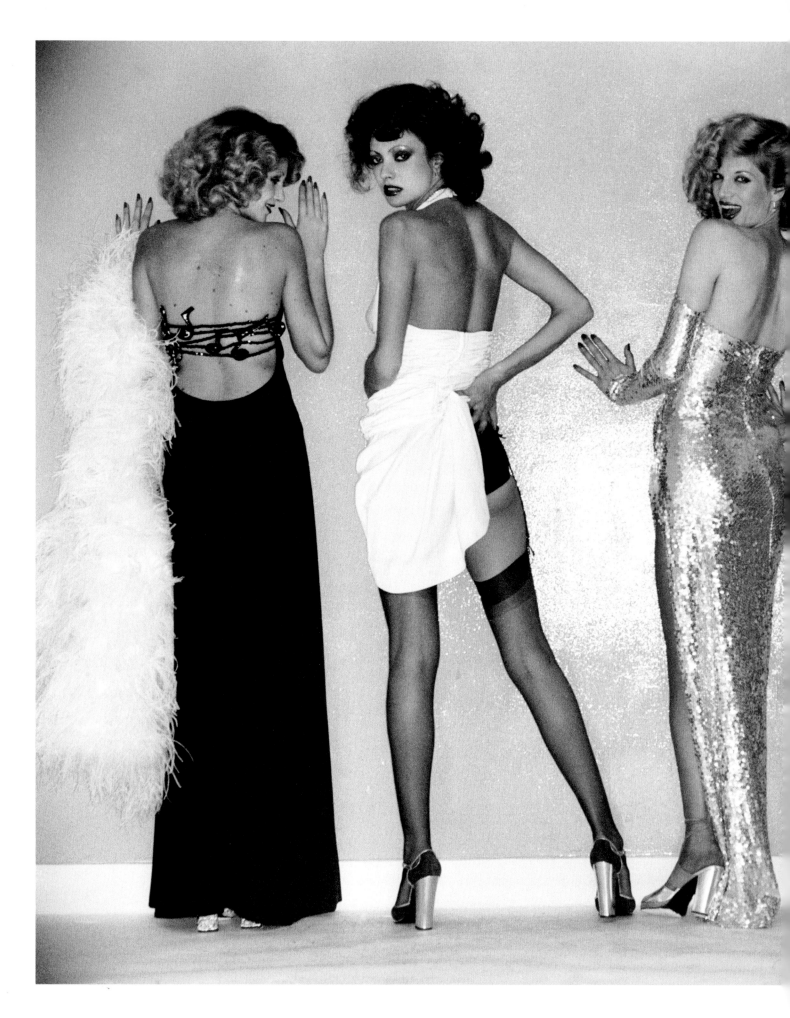

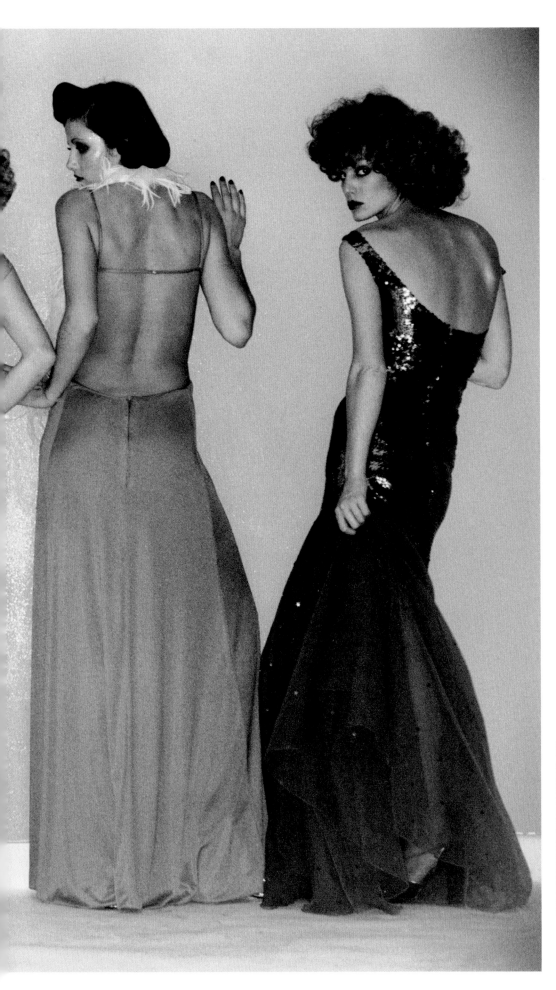

JESSICA JONES PRESENTS FIVE INCARNATIONS OF AMERICAN ACTRESS JEAN HARLOW. FROM LEFT TO RIGHT: BACKLESS JERSEY BUSTIER DRESS WITH BOA AND HORIZONTAL SEQUIN BACK STRAPS EMBELLISHED WITH MUSIC NOTES; *MARYLIN* SILK-CREPE DRESS WITH CUTAWAY SLEEVES; GOLD SEQUIN BUSTIER SHEATH DRESS WITH SIDE SLIT; BACKLESS SEQUINED *CŒUR* DRESS WITH FLARED JERSEY SKIRT AND BOA; ASYMMETRICAL SEQUINED DRESS WITH CHIFFON SKIRT STUDDED WITH SEQUINS. PHOTOGRAPHED FOR *STERN* MAGAZINE.

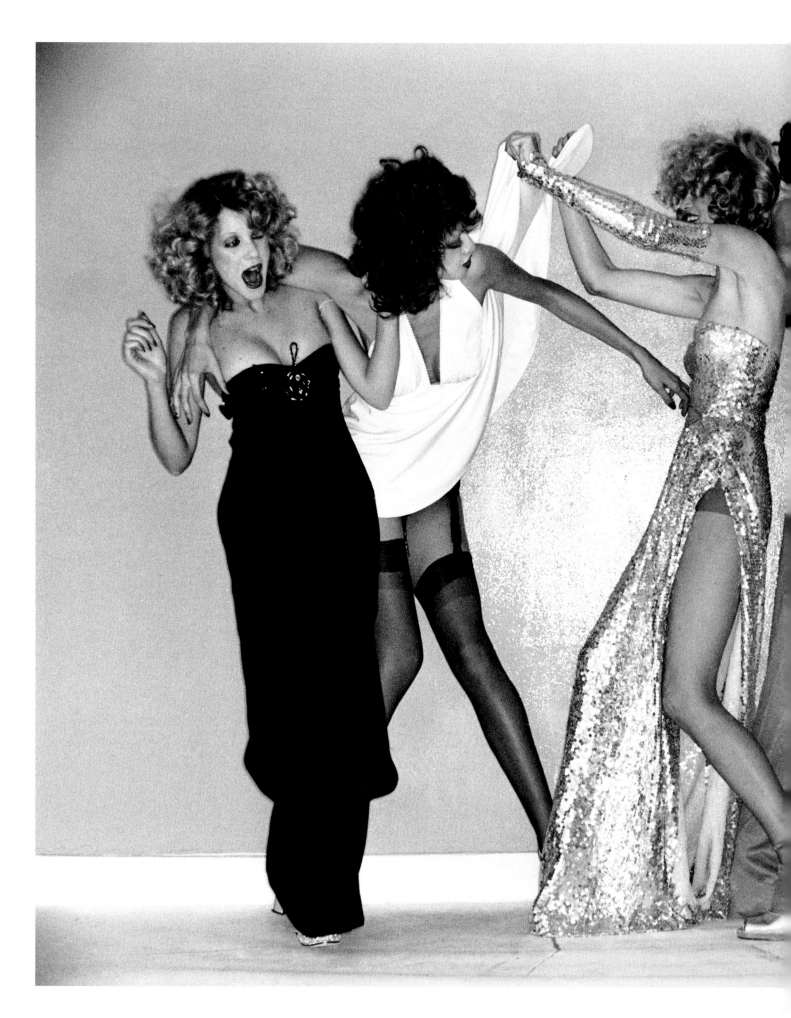

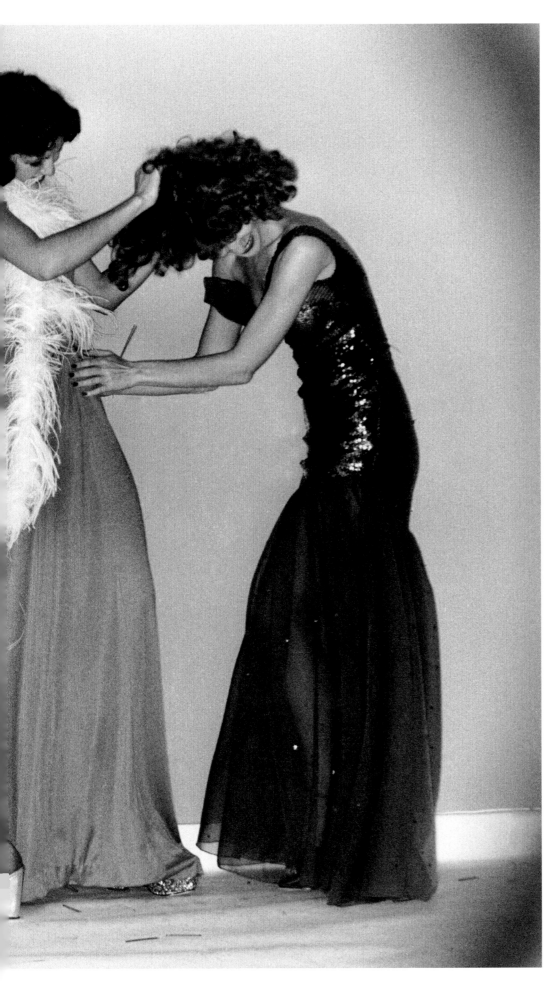

JESSICA JONES
AGAIN, THIS TIME IN A
PHOTOMONTAGE DEPICTING
A CATFIGHT BETWEEN FIVE
LOVELIES WEARING THE SAME
DRESSES AS IN THE PREVIOUS
DOUBLE-PAGE SPREAD.
THE PHOTO WOULD LATER
INSPIRE THE 1978 FILM THRILLER,
THE EYES OF LAURA MARS,
DIRECTED BY IRVIN KERSHNER.

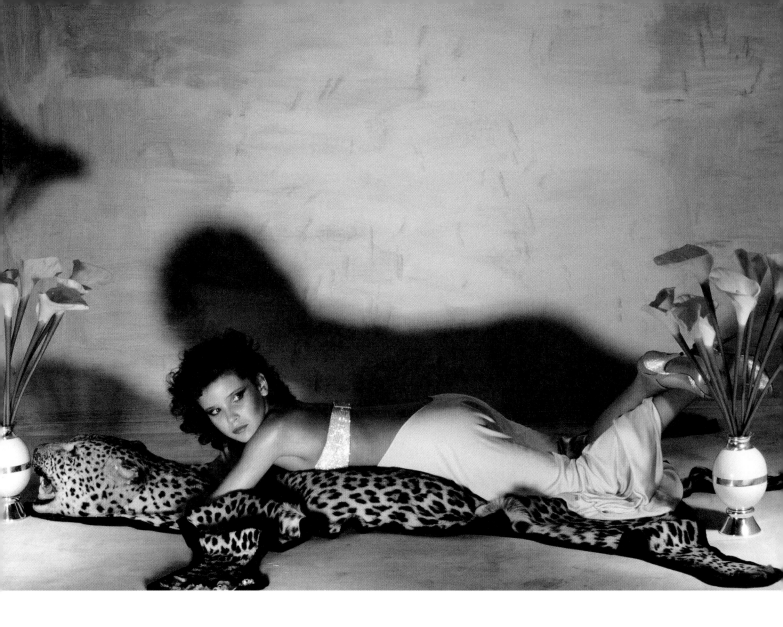

/ CATHERINE AZZARO,
PHOTOGRAPHED
FOR *VOGUE PARIS* IN 1978,
WEARING SWAROVSKI
CRYSTAL EMBROIDERED JERSEY
SKIRT WITH MATCHING BRA,
RECLINING ON A ROBERT
BEAULIEU FUR.

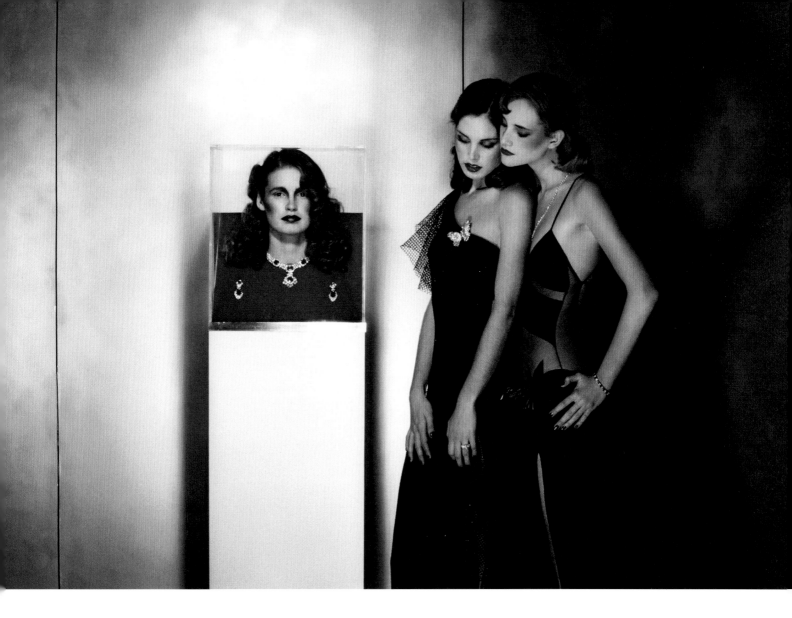

SUPERMODEL YVONNE
SPORRE AND FRIEND,
PHOTOGRAPHED IN 1979
FOR *VOGUE PARIS*.
LEFT: ASYMMETRICAL SILK CREPE
AND MESH SHEATH DRESS.
RIGHT: JERSEY AND CHIFFON
DRESS WITH STRAPS. JEWELRY
BY VAN CLEEF & ARPELS.

I ALWAYS WORK WITH THE SAME BASE, SEXY, ACCENTUATED CURVES, SHEERNESS, DÉCOLLETÉ, BARE BACKS, BUT VEILED. AND NEVER MORE THAN TWO FABRICS SO AS NOT TO INTERFERE WITH THE SILHOUETTE.

Loris Azzaro

/ AN EROTIC EVOCATION OF NIGHTLIFE: LORIS AZZARO, PHOTOGRAPHED NAKED IN 1975, WITH THREE 'SEVENTIES SUPERMODELS. IN THE CENTER, SWEDISH MODEL GUNILLA LINDBLAD WEARS A SILK CREPE SHEATH DRESS WITH CALAIS LACE DETAILING. THE MODEL ON THE LEFT WEARS A SEQUIN EMBROIDERED SILK CHIFFON SHEATH DRESS. THE MODEL ON THE RIGHT WEARS A BACKLESS FLARED JERSEY SHEATH DRESS WITH DIAMANTE STRAPS THAT ATTACH TO FORM A FLOWER IN THE MIDDLE OF THE BACK.

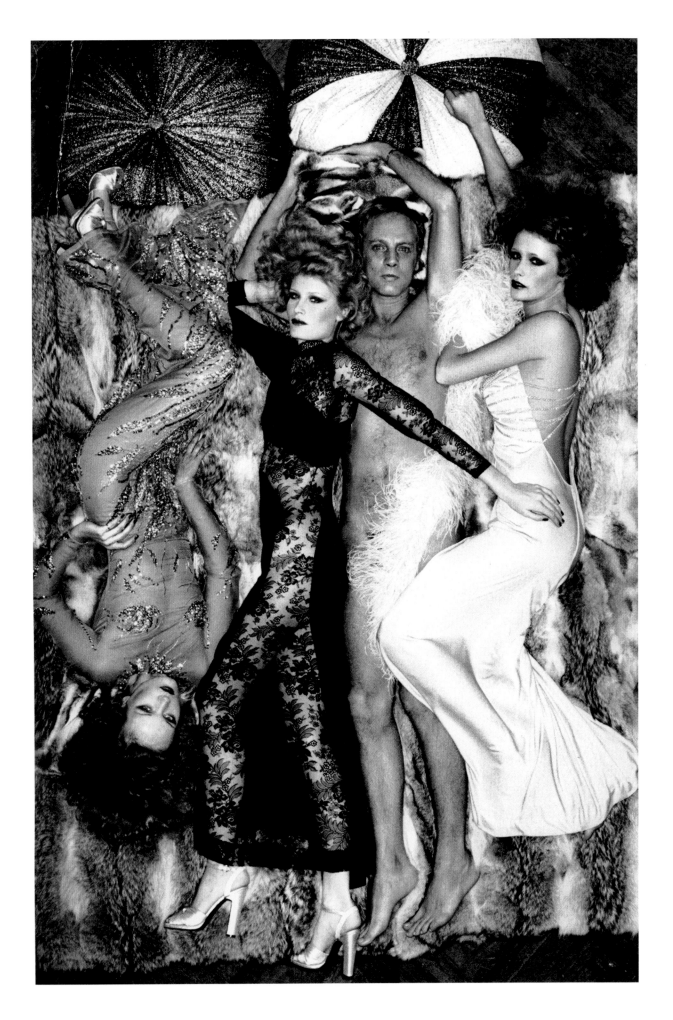

LORIS
AND THE PRESS

From the start of his career, photos of
his creations were featured in the pages
of the biggest fashion magazines,
such as *Vogue, L'Officiel de la Couture,
Harper's Bazaar,* and *Elle.* A media
sensation that owed as much to the
photogenic quality of his dresses as
to the festive and sensual atmosphere
they evoked.

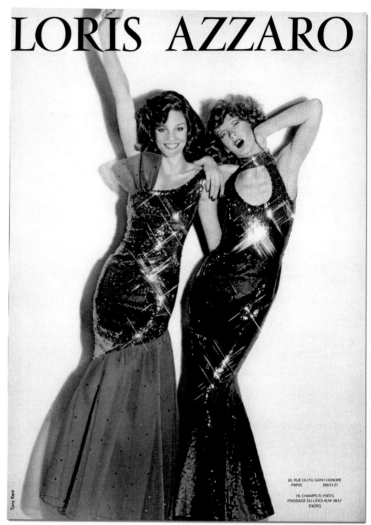

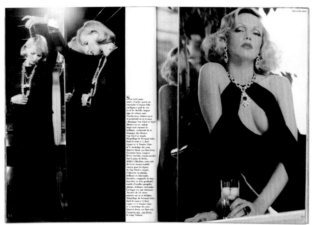

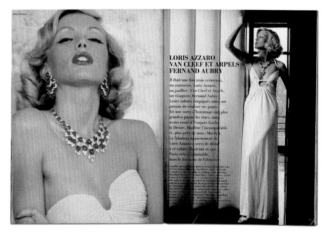

/ **ABOVE AND LEFT:**
HOMAGE TO GRETA
GARBO, MARLENE DIETRICH
AND MARILYN MONROE,
PHOTOGRAPHED IN LORIS
AZZARO'S APARTMENT.
ORIGINALLY PUBLISHED IN
1975 IN ISSUE 618 OF *L'OFFICIEL
DE LA COUTURE.*

/ **TOP:** TWO DESIGNS
FEATURED IN A SUMMER
1973 READY-TO-WEAR SPECIAL
ISSUE OF *JOUR DE FRANCE*
MAGAZINE.

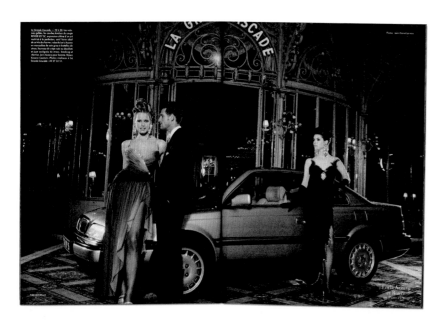

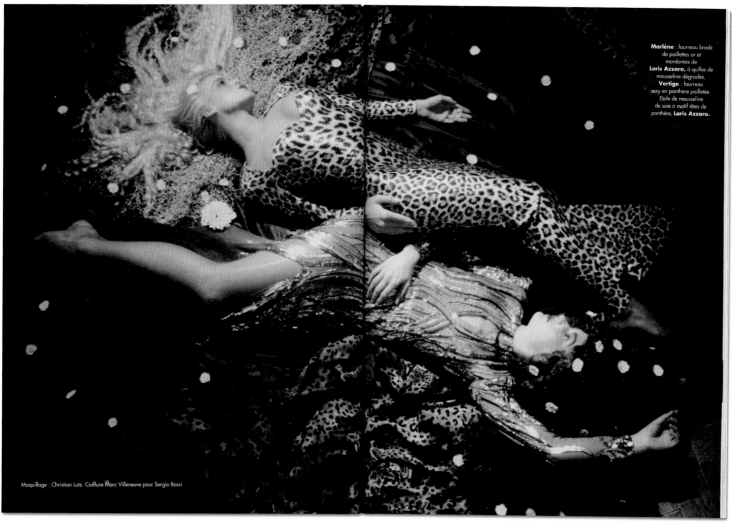

Marlène : fourreau brodé
de paillettes or et
mordorées de
Loris Azzaro, à quilles de
mousseline dégradée,
Vertige : fourreau
sexy en panthère pailletée.
Étole de mousseline
de soie à motif têtes de
panthère, **Loris Azzaro.**

Maquillage : Christian Lutz. Coiffure Marc Villeneuve pour Sergio Bossi

Jean-Daniel Lorieux

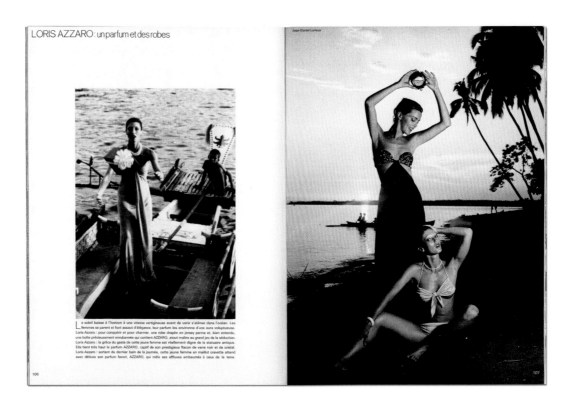

TOP: JERSEY DRAPE DRESS FEATURED IN 1977 IN ISSUE 638 OF *L'OFFICIEL DE LA COUTURE.*

BELOW: *LEFT,* VISUAL FOR *COUTURE* PERFUME; *RIGHT,* DESIGNS FEATURED IN 1976 IN ISSUE 624 OF *L'OFFICIEL DE LA COUTURE*

Le soleil baisse à l'horizon à une vitesse vertigineuse avant de venir s'abîmer dans l'océan. Les femmes se parent et font assaut d'élégance, leur parfum les environne d'une aura voluptueuse. Loris Azzaro : pour conquérir et pour charmer, une robe drapée en jersey parme et, bien entendu, une boîte précieusement enrubannée qui contient AZZARO, atout maître au grand jeu de la séduction. Loris Azzaro : la grâce du geste de cette jeune femme est réellement digne de la statuaire antique. Elle tient très haut le parfum AZZARO, captif de son prestigieux flacon de verre noir et de cristal. Loris Azzaro : sortant du dernier bain de la journée, cette jeune femme en maillot crevette attend avec délices son parfum favori, AZZARO, qui mêle ses effluves embaumés à ceux de la terre.

106

107

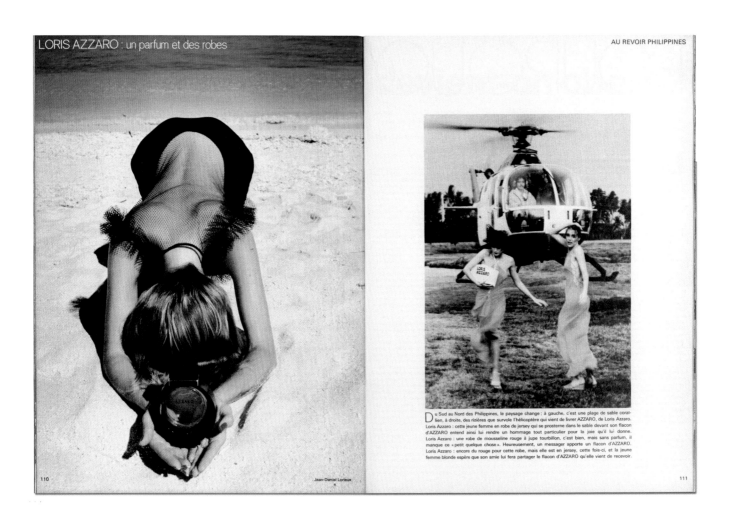

Jean-Daniel Lorieux

Du Sud au Nord des Philippines, le paysage change : à gauche, c'est une plage de sable corallien, à droite, des rizières que survole l'hélicoptère qui vient de livrer AZZARO, de Loris Azzaro. Loris Azzaro : cette jeune femme en robe de jersey qui se prosterne dans le sable devant son flacon d'AZZARO entend ainsi lui rendre un hommage tout particulier pour la joie qu'il lui donne. Loris Azzaro : une robe de mousseline rouge à jupe tourbillon, c'est bien, mais sans parfum, il manque ce « petit quelque chose ». Heureusement, un messager apporte un flacon d'AZZARO. Loris Azzaro : encore du rouge pour cette robe, mais elle est en jersey, cette fois-ci, et la jeune femme blonde espère que son amie lui fera partager le flacon d'AZZARO qu'elle vient de recevoir.

110

111

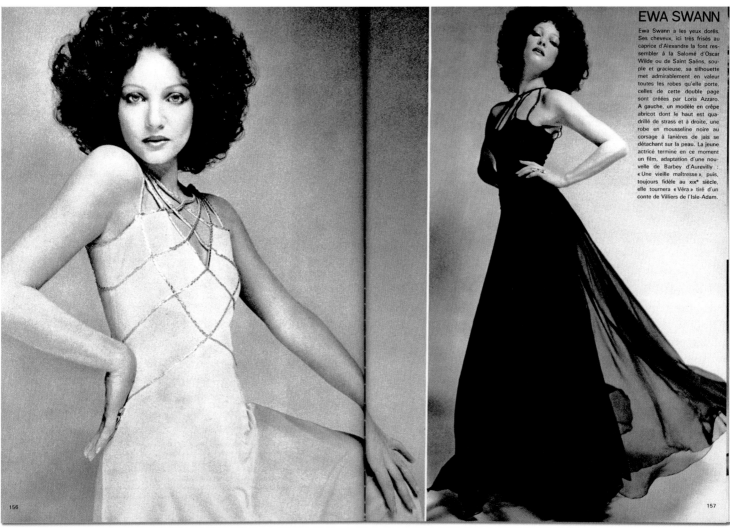

EWA SWANN

Ewa Swann a les yeux dorés. Ses cheveux, ici très frisés au caprice d'Alexandre la font ressembler à la Salomé d'Oscar Wilde ou de Saint Saëns, souple et gracieuse, sa silhouette met admirablement en valeur toutes les robes qu'elle porte, celles de cette double page sont créées par Loris Azzaro. A gauche, un modèle en crêpe abricot dont le haut est quadrillé de strass et à droite, une robe en mousseline noire au corsage à lanières de jais se détachant sur la peau. La jeune actrice termine en ce moment un film, adaptation d'une nouvelle de Barbey d'Aurevilly : « Une vieille maîtresse », puis, toujours fidèle au xix° siècle, elle tournera « Véra » tiré d'un conte de Villiers de l'Isle-Adam.

LORIS AZZARO : un parfum et des robes

.BONJOUR PHILIPPINES

Arrivées dans la journée même à Manille, elles vont vivre leur première soirée au Hyatt. Pour personnaliser leur appartement, elles ont fixé au mur un flacon de leur parfum : AZZARO. Elles en apprécient toutes les deux la note dominante : fleurie, verte, chyprée, boisée. Ce parfum est pour elles comme une seconde peau et elles doivent beaucoup de leur charme à sa fragrance et à l'invisible sillage qu'il laisse derrière elles.

Loris Azzaro : la jeune femme brune porte une robe très sexy pour mettre son bronzage en valeur. Parmi les composantes de son parfum, elle apprécie tout particulièrement les épices, l'ylang ylang, la tubéreuse, le santal et le jasmin qui conviennent parfaitement bien à sa beauté capiteuse.

Loris Azzaro : la jeune femme blonde en robe d'ange à grosse broderie argent trouve dans son parfum, qui est le même, des suavités qui la ravissent, l'iris de Florence, la jacinthe, le gardénia et la pêche lui paraissent en parfaite harmonie avec ce qui se soit sa beauté blonde si délicat et de pur.

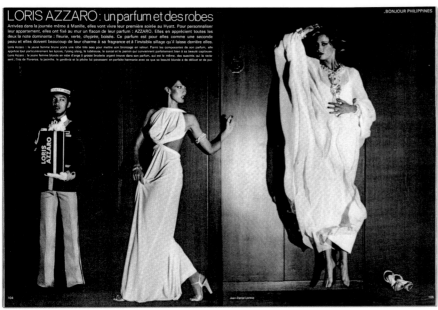

Jean-Daniel Lorieux

TOP: ACTRESS EWA SWAN MODELING TWO DESIGNS FEATURED IN 1974 IN ISSUE 612 OF *L'OFFICIEL DE LA COUTURE*

LEFT: JERSEY DRESS AND SILVER EMBROIDERED CHIFFON DRESS FEATURED IN 1976 IN ISSUE 624 OF *L'OFFICIEL DE LA COUTURE.*

LORIS AND HIS MUSES

He dressed the world's most beautiful women, and the most famous too—actresses, singers, performers, and princesses. Most of them became friends, inspirations or associates. "They are the reason I became famous," he said.

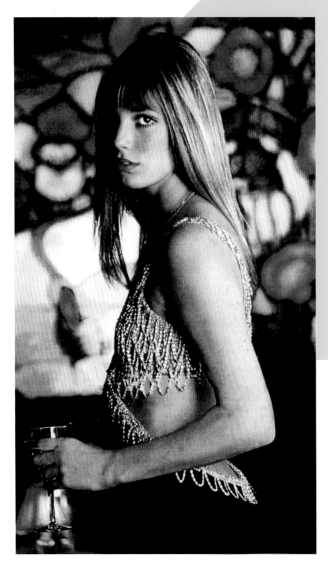

LEFT: ACTRESS AND SINGER JANE BIRKIN WEARING BACKLESS *SALOMÉ* JERSEY DRESS WITH GOLD LUREX MESH AND CHAIN TOP, 1970S.

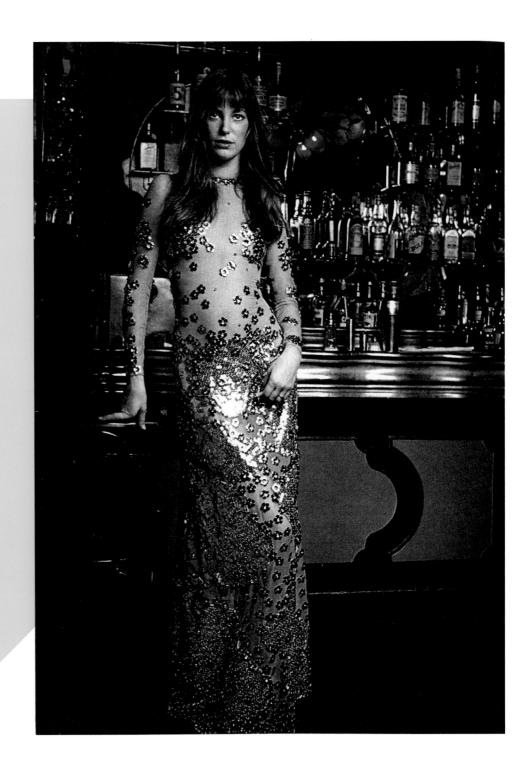

JANE BIRKIN IN
A TRANSPARENT
GOLD SEQUIN EMBROIDERED
CHIFFON SHEATH DRESS,
PHOTOGRAPHED AT THE
CHEZ CASTEL CLUB IN 1972.

SOME OF MY FAMOUS CUSTOMERS HAVE BECOME FRIENDS, I OWE THEM A LOT, FOR THEY ARE THE REASON I'M KNOWN TODAY. WE MADE A DEAL. I MADE THEM BEAUTIFUL AND THEY MADE ME FAMOUS.

Loris Azzaro

/ SINGER TINA TURNER
IN *VERSEAU* LUREX AND
CHAIN DRESS PERFORMING
AT THE PARIS OLYMPIA, 1971.

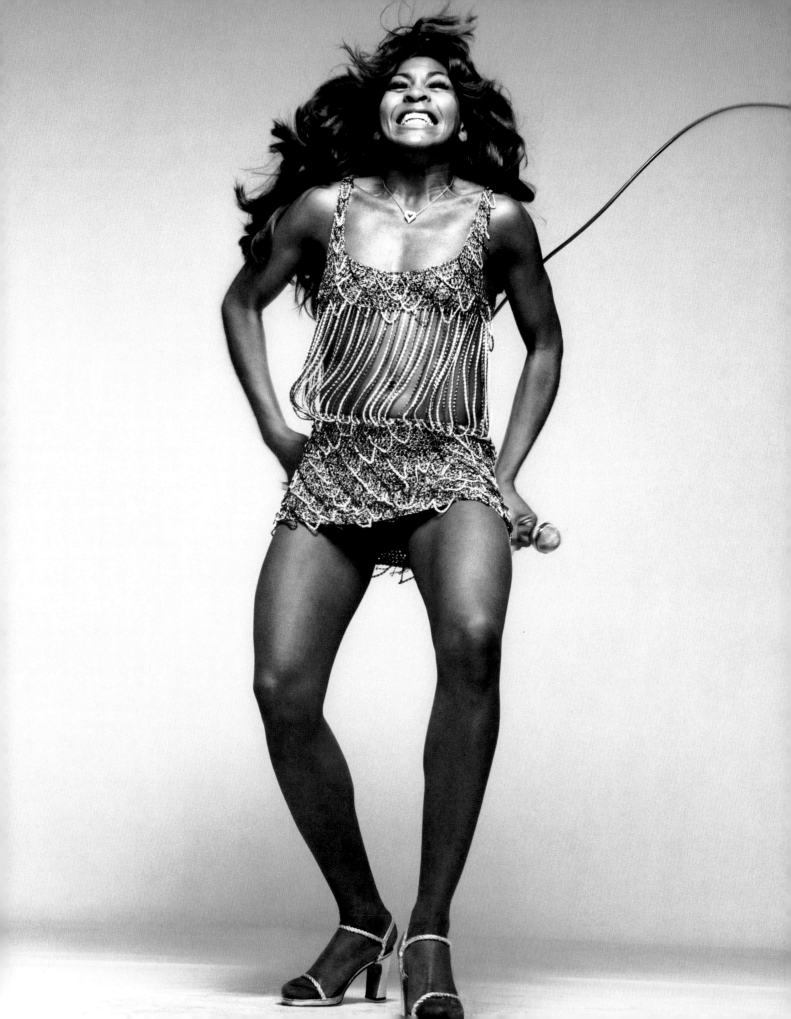

NOTHING IS DIFFICULT WITH DALIDA, SHE CAN WEAR ANYTHING.

Loris Azzaro

/ FRENCH SINGER DALIDA
IN A SILK CHIFFON BUSTIER
SHEATH DRESS EMBROIDERED
WITH MIRROR SEQUINS
ALSO CREATED IN SILVER
AND TURQUOISE.

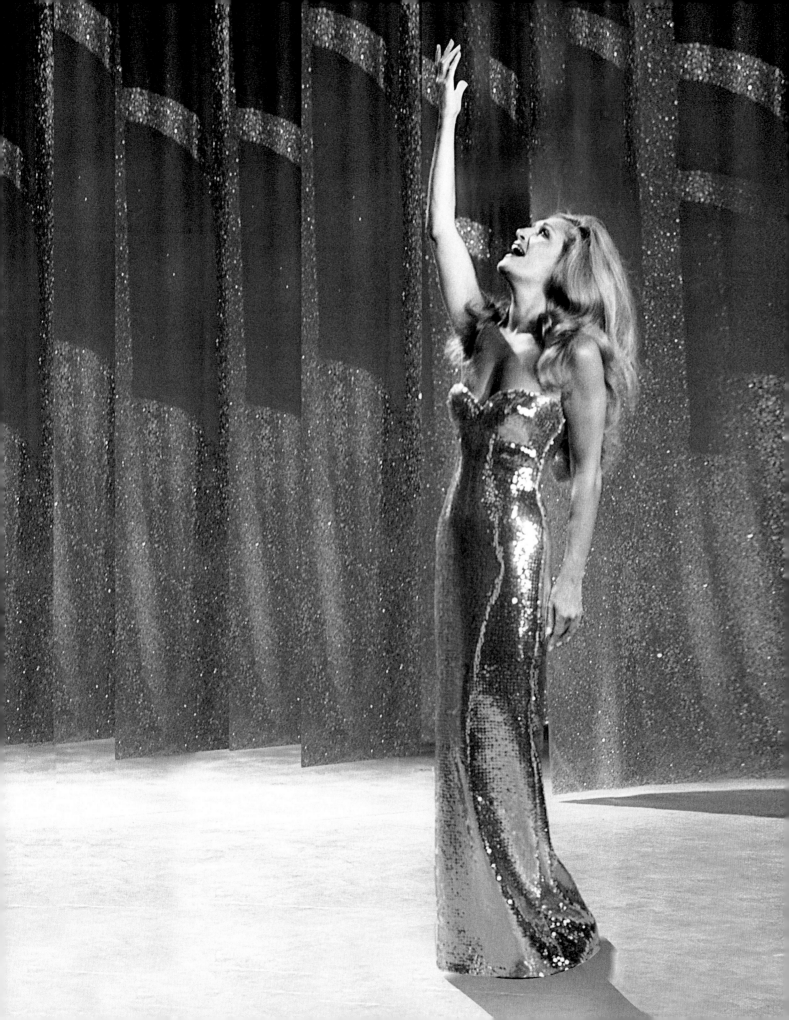

/ **ABOVE:** FRENCH SINGER
SHEILA IN A SWAROVSKI
CRYSTAL- EMBROIDERED JERSEY
DRESS, PICTURED WITH LORIS
AZZARO, 1970S.

/ **RIGHT:** ACTRESS CLAUDIA
CARDINALE WITH LORIS
AZZARO IN A FITTING FOR
THE FILM *POPSY POP*, PICTURED
IN THE FAUBOURG SAINT
HONORÉ BOUTIQUE, 1970S.

/ **ABOVE:** ACTRESS ROMY
SCHNEIDER IN JERSEY
SHEATH DRESS WITH MATCHING
CHOKER (MICHELLE AZZARO
DESIGN), WITH MICHEL PICCOLI
IN CLAUDE SAUTET'S FILM *MAX
AND THE JUNKMEN* (1971).

/ **RIGHT:** ROMY SCHNEIDER
WEARING A LORIS
AZZARO DRESS IN CLAUDE
CHABROL'S *INNOCENTS
WITH DIRTY HANDS* (1974).

/ ACTRESS AND SINGER
VANESSA PARADIS
WEARING A *VERSEAU* LUREX
AND CHAIN TOP, IN CONCERT
AT THE CASINO DE PARIS
IN 2010.

/ **OPPOSITE PAGE:** ACTRESS
CAROLYN MURPHY
WEARING *BABA* DRESS AT THE
2003 MET GALA, NEW YORK.

BELOW: FROM LEFT TO RIGHT, KATE MOSS IN *IMAGINE* SILK CREPE BOILER SUIT (VANESSA SEWARD FOR AZARRO, AUTUMN/WINTER 2010/2011); AMERICAN ACTRESS NATALIE PORTMAN IN *JESSICA* PLEATED CHIFFON DRESS (VANESSA SEWARD FOR AZZARO, SPRING/ SUMMER 2011) AT THE GOLDEN GLOBE AWARDS, BEVERLEY HILLS; AMERICAN ACTRESS KRISTEN STEWART IN *GRAFFITI* SWAROVSKI CRYSTAL EMBROIDERED WOOL CREPE DRESS (VANESSA SEWARD FOR AZZARO, *INTEMPORELLE* COLLECTION) AT THE PACIFIC DESIGN CENTER, LOS ANGELES, FOR THE FILM PREMIER OF *THE YELLOW HANDKERCHIEF*, 2010.

OPPOSITE PAGE: ACTRESS ANNE HATHAWAY WEARING *EUGENIE* DRESS AT THE 15TH ANNUAL SCREEN ACTORS GUILD AWARDS, LOS ANGELES, 2009.

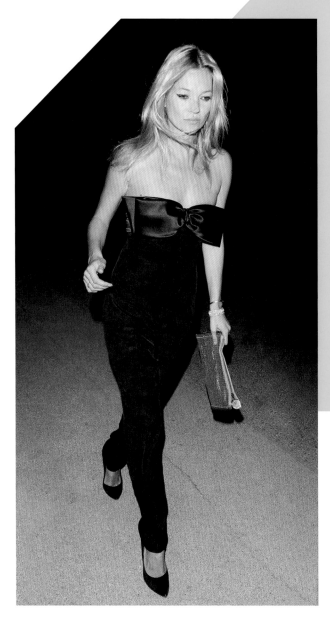

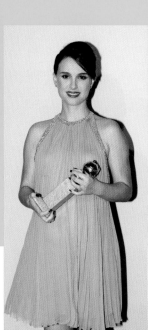

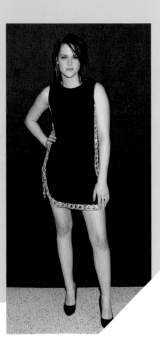

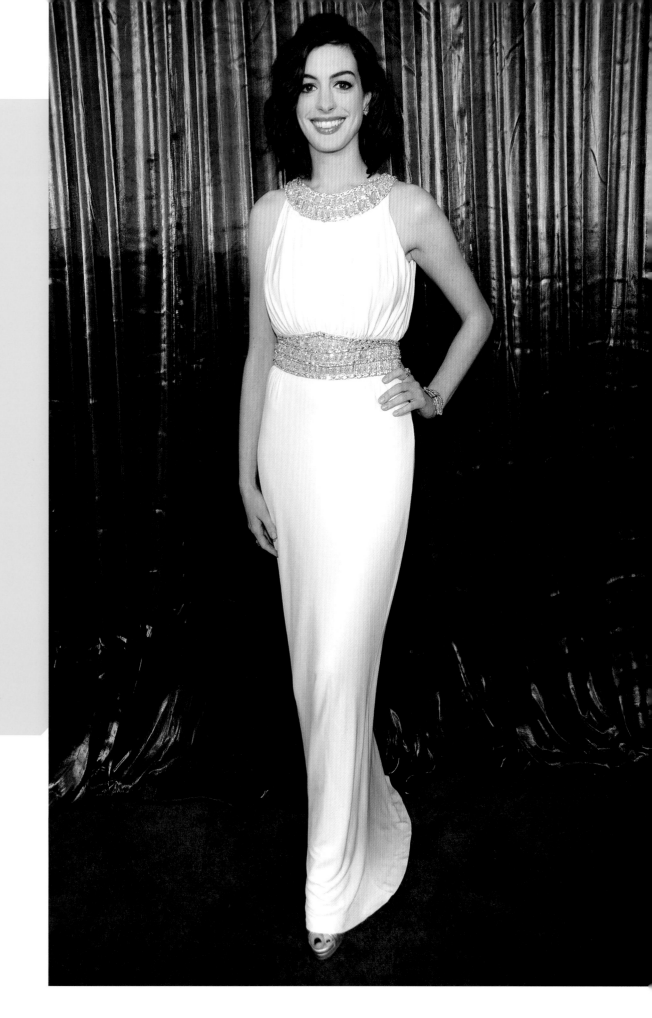

/ ABOVE, RIGHT AND
FOLLOWING PAGE: LORIS
AZZARO CIRCA 1979.

I DON'T REALLY
GET THE FEELING
I'M A DESIGNER.
I FEEL MORE
LIKE AN ARTIST.
I'M DRAWN TO
ALL OF THE ARTS…
DEEP DOWN,
I'M A LITTLE
NEIGHBORHOOD
DRESSMAKER.
I'M HAVING WAY
TOO MUCH FUN
TO BE A DESIGNER.

Loris Azzaro

SAVOIR-FAIRE

Behind every Azzaro dress lie the secrets executed
in silence and the joyful flurry of activity in the ateliers.
This savoir-faire garnered from experience or at top
fashion schools gives rise to the beaded goldwork
embroidery, the draped fabrics that seem to hang
by a thread and the lamés that shimmer in the
light. This art of excellence, which can be seen as
much in the details of a dress as in its overall shape,
is a human story, the result of meticulous learning
and precise, skillful manufacturing that renders each
of his creations unique, timeless and alive.
The art of drapery is one of the greatest strengths
of the Azzaro house. Predominantly applied to
the sheath dress, the beautifully draped folds
are often reinterpreted—without ever copying—
Madame Grès's famous designs.
Pleating is also a key element in the history of the
house, as are its crystal embellishments, gold leaf
finishing, creation of silicone fabric and, of course,
embroidery on bib fronts and in patterns. True talent
often leads to meaningful encounters. Loris Azzaro
began working with the Lesage embroidery studio
in the 1970s. He also worked with Swarovski for its
famous crystals and decorative gemstones, with
Lemarié for its feather art and handmade fabric
flowers, and the house of Lognon for its renowned
hand pleating. But as with a fragrance or recipe
those skills are nothing without choice ingredients.
A devotee of fabrics that dressed women to reveal
them, Loris Azzaro adored jersey, silk, crepe and
organza, not to mention jacquard, chiffon lamé,
charmeuse and tulle... All sensual, luminous fabrics
to help to create a dress and forge a legend.

/ DETAIL OF *ARTÉMIS*
CREPE AND SWAROVSKI
CRYSTAL EMBROIDERED DRESS,
SPRING/SUMMER 2017.

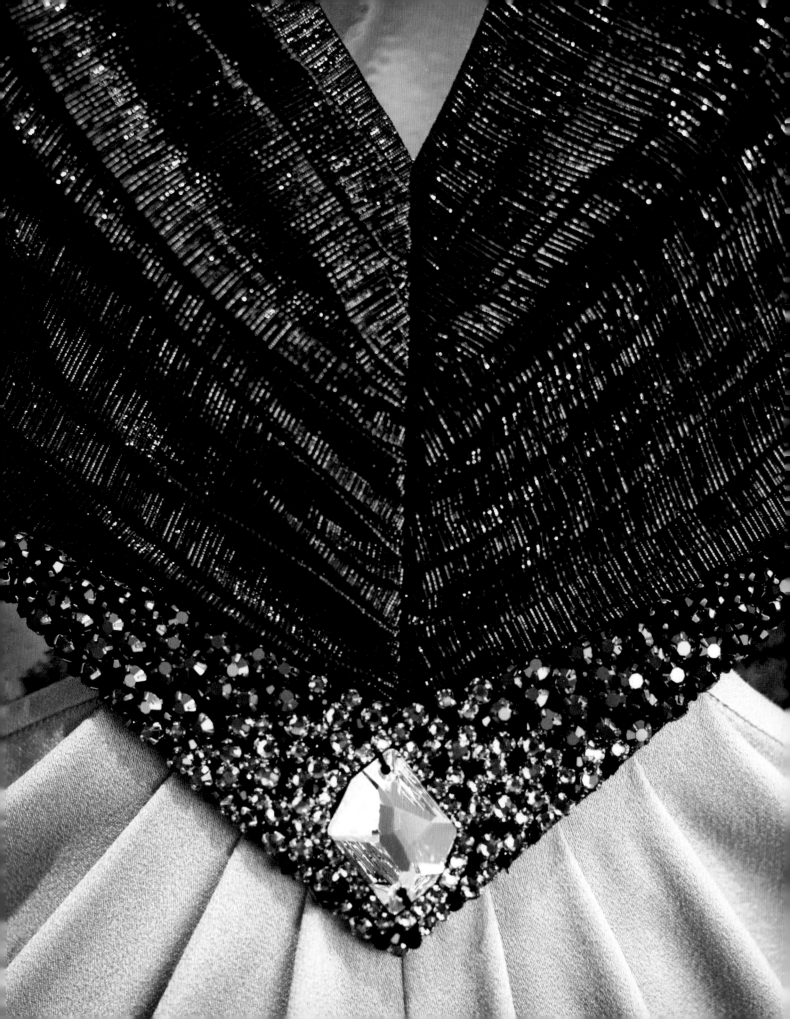

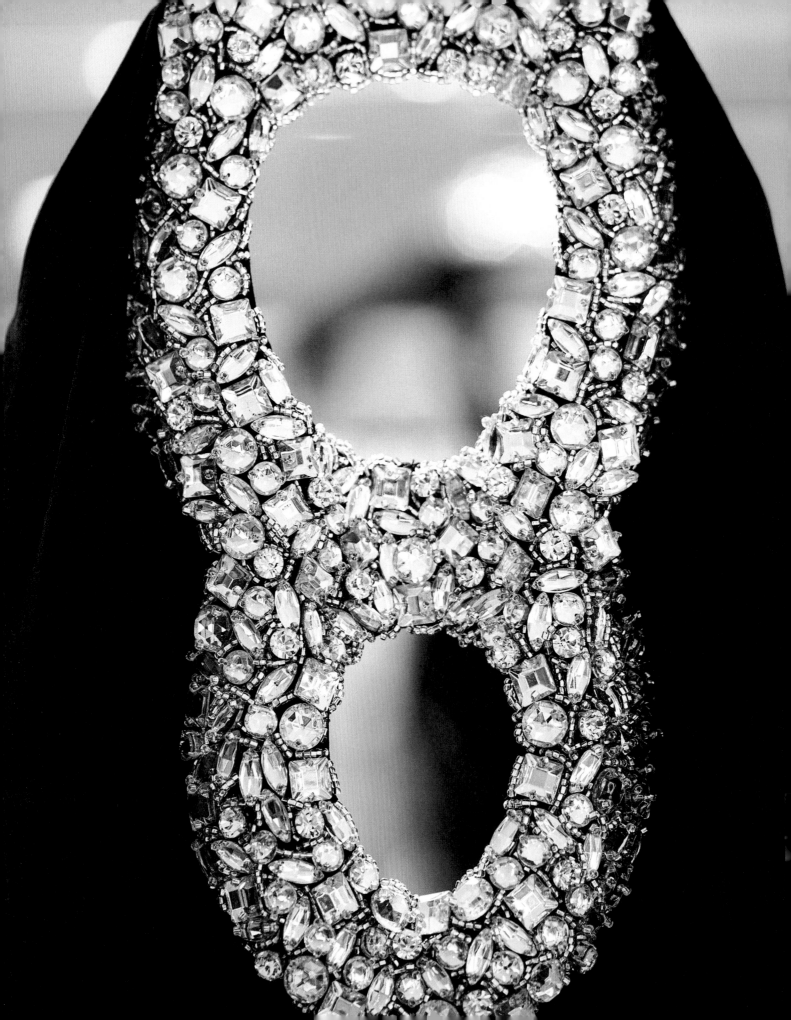

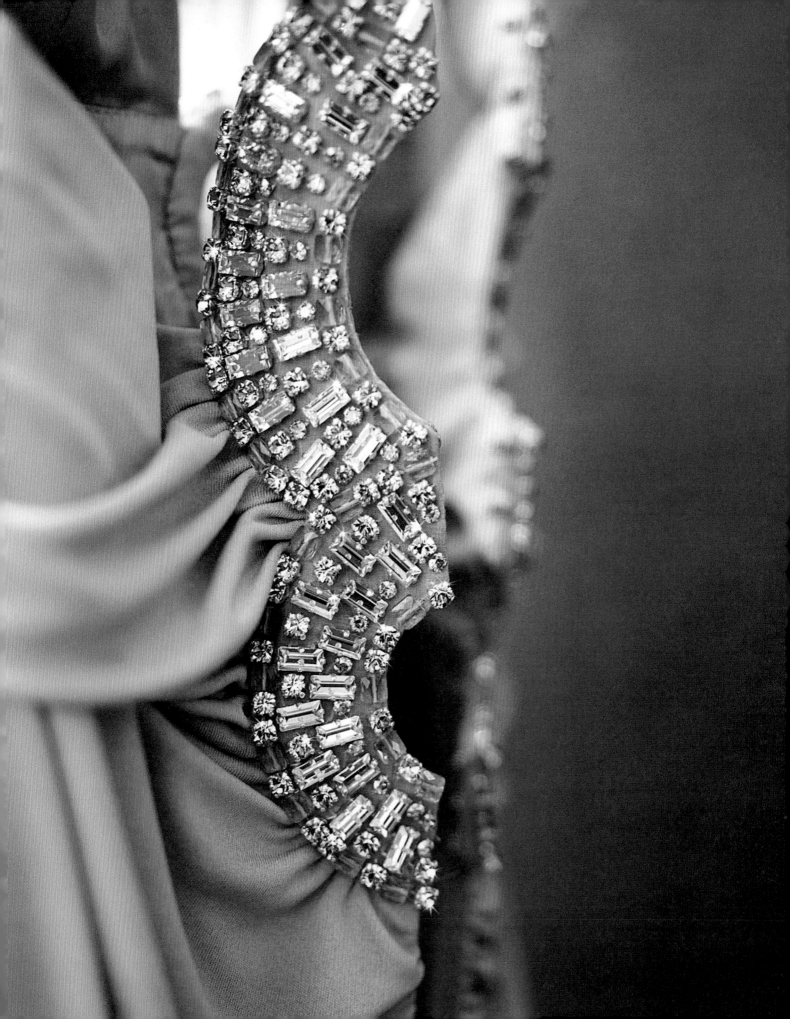

PAGES 90-91: DETAIL OF *TROIS ANNEAUX* SWAROVSKI CRYSTAL EMBROIDERED JERSEY DRESS, WITH (*CENTER*) DETAIL OF ITS NEW, *AMBRE* JERSEY AND SWAROVSKI CRYSTAL INCARNATION, SPRING/SUMMER 2017.

ATELIER DIRECTOR MICHELINE IN THE FAUBOURG SAINT-HONORÉ ATELIER.

RIGHT: DETAIL OF *ARIZONA* JERSEY DRESS WITH BACK EMBELLISHED WITH WOODEN BEADS, SPRING/SUMMER 2017.

FOLLOWING PAGE: DETAILS OF *TERRENCE* LAME SUN PLEAT DRESS.

PAGE 96: *JENNA* JERSEY DRAPE DESIGN AND *NUCIA* SWAROVSKI-EMBROIDERED DESIGN (AZZARO *INTEMPORELLE* COLLECTION).

PAGE 97: DETAIL OF *ALPHA* CREPE DRESS WITH SIDE LACING, SPRING/SUMMER 2017.

PAGES 98-99: DETAILS OF SWAROVSKI CHAIN EMBROIDERY ON *GRAFFITI* DRESS.

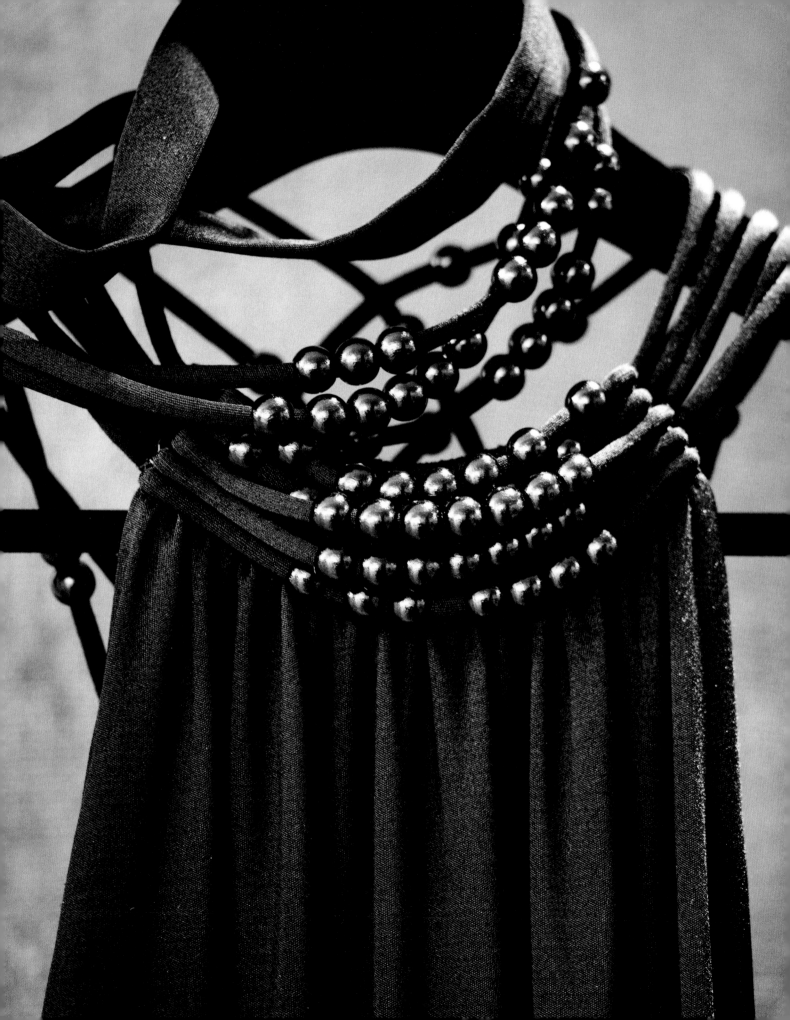

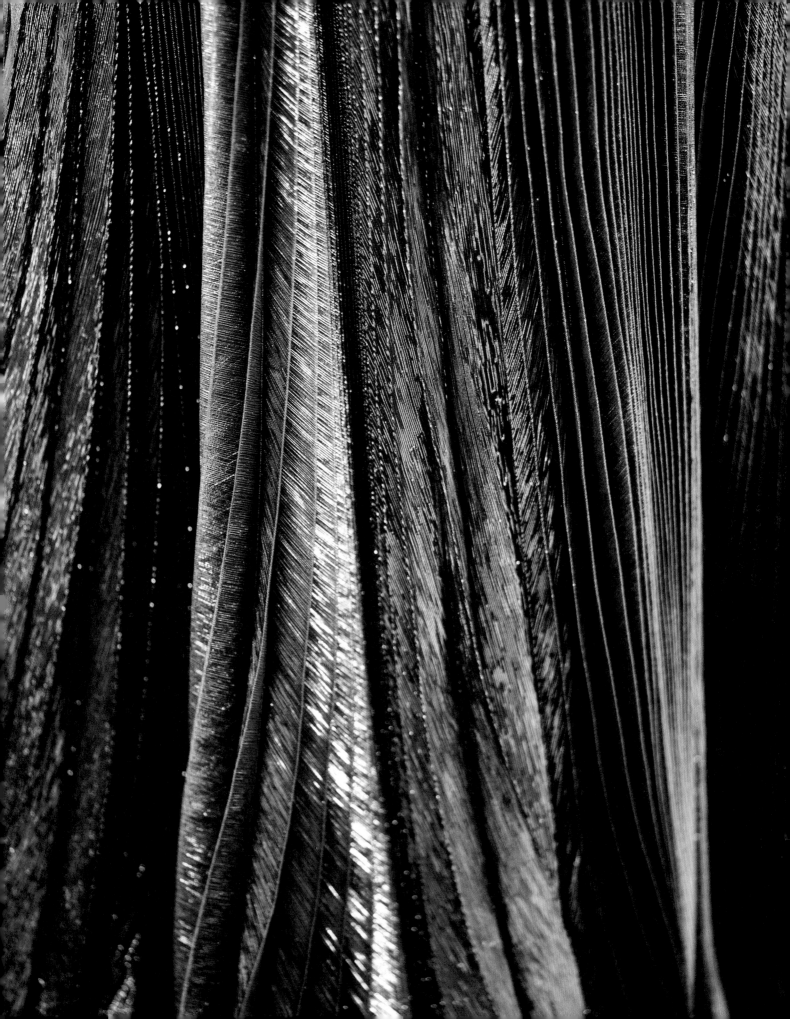

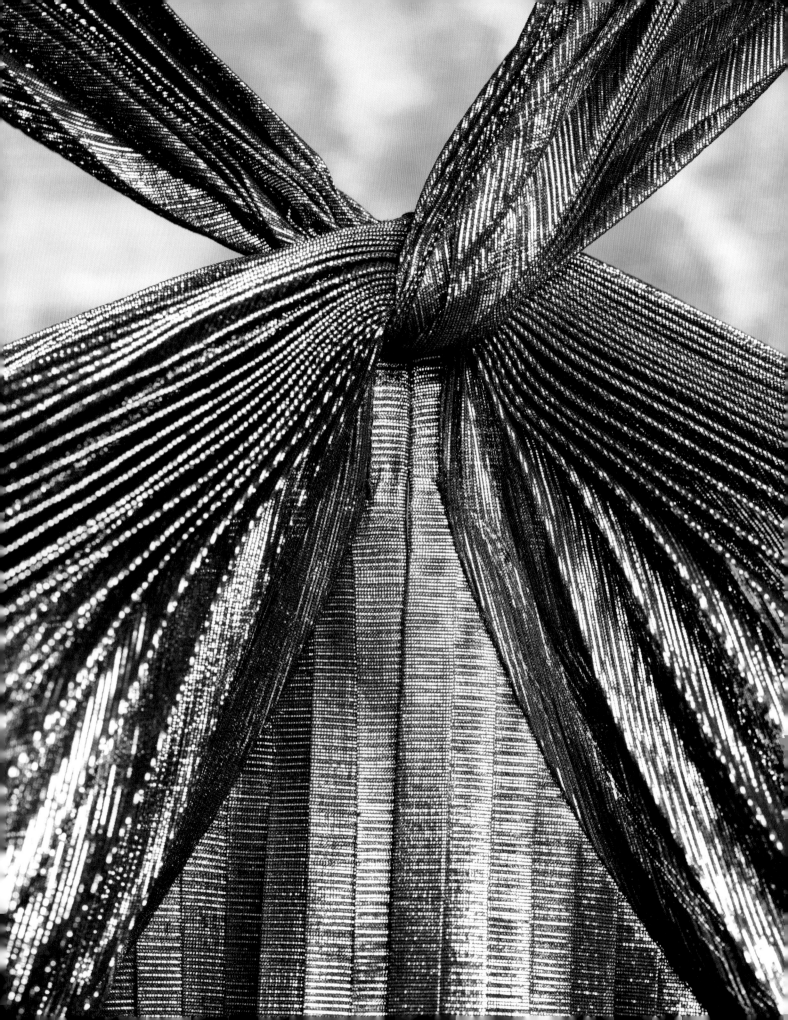

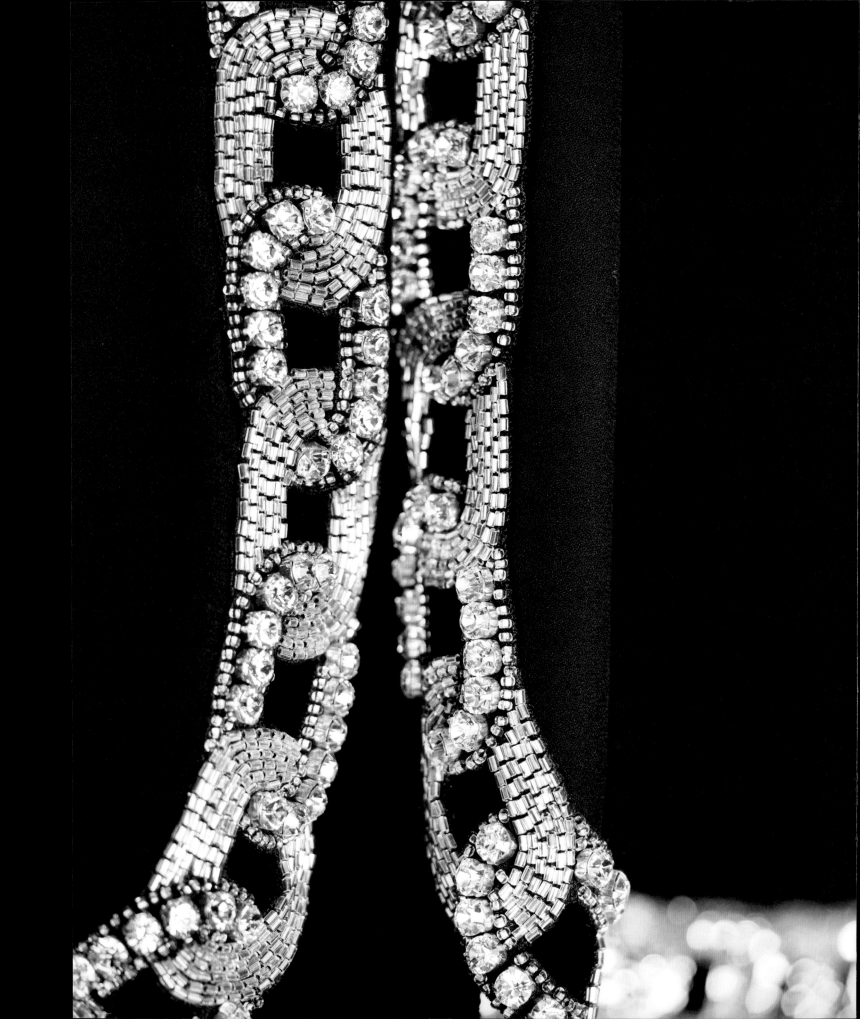

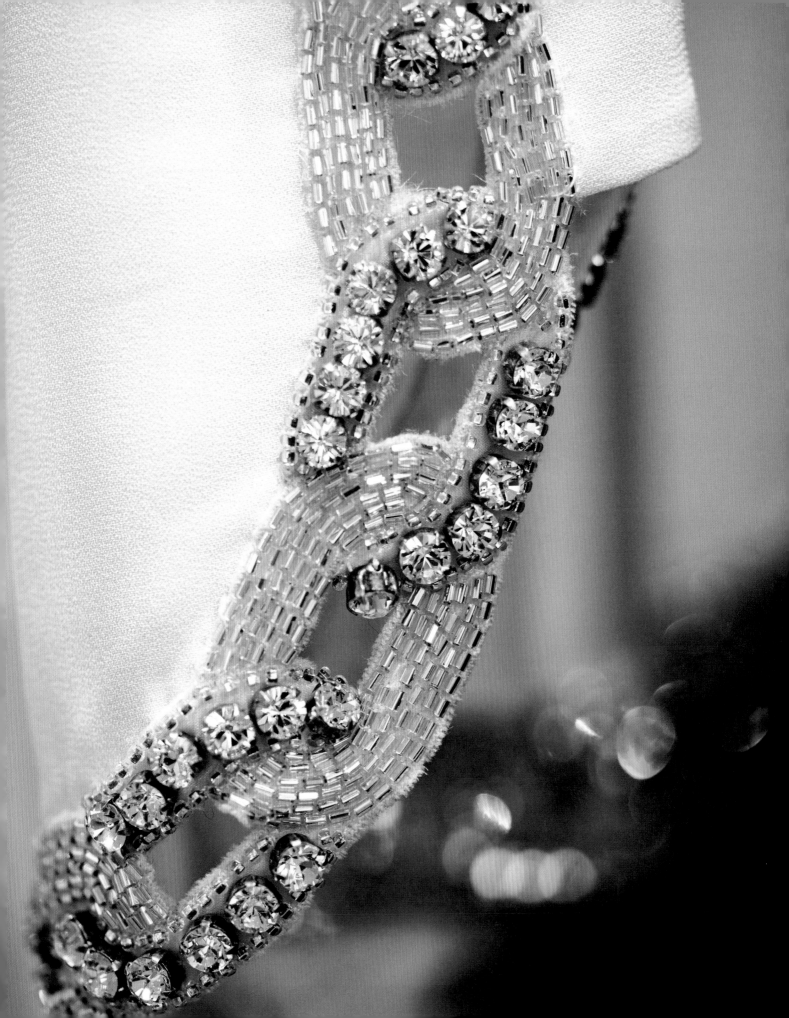

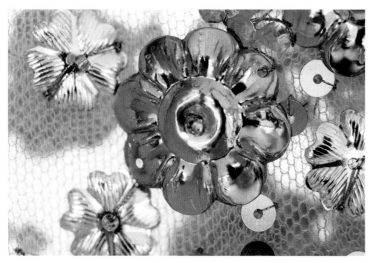

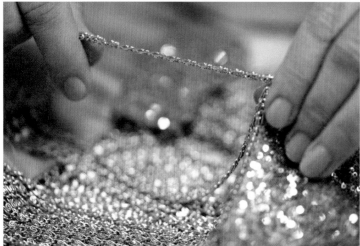

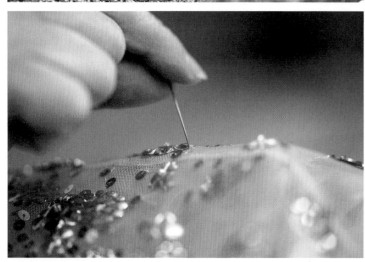

DETAILS OF *AMAZONIA* ENTIRELY HAND-EMBROIDERED TULLE DRESS, SPRING/SUMMER 2017.

FOLLOWING PAGES: LORIS AZZARO *INTEMPORELLE* DESIGNS ON A RAIL IN THE FAUBOURG SAINT HONORÉ BOUTIQUE.

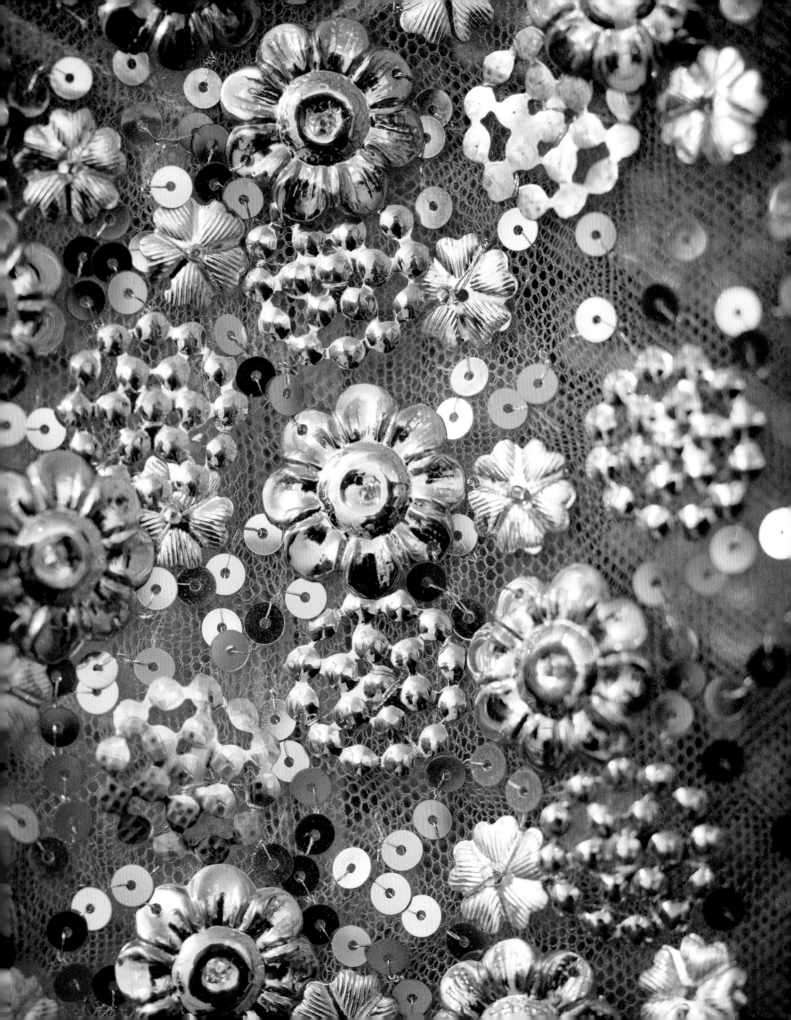

THE
WORLD OF
FRAGRANCE

**A PERFUMED
JOURNEY**

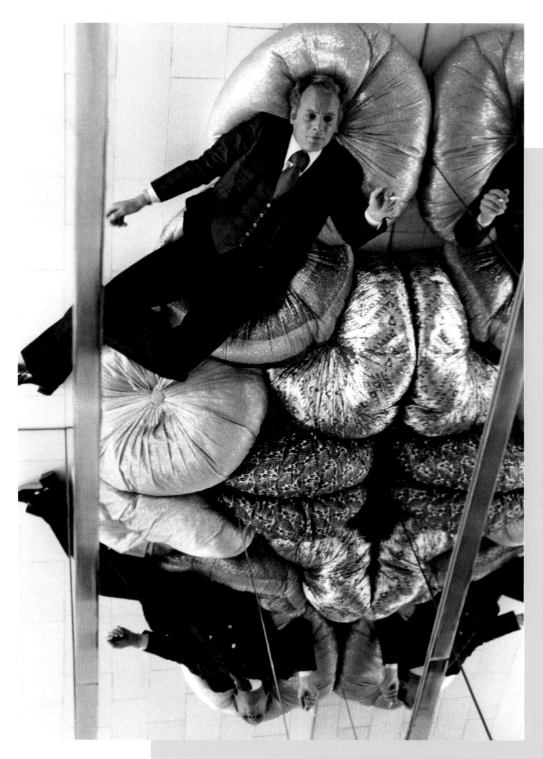

/ LORIS AZZARO
PHOTOGRAPHED
IN 1977 RECLINING ON
DAVID RUCLI LAME
CUSHIONS IN HIS APARTMENT
ON THE AVENUE DU
MARÉCHAL MAUNOURY,
PARIS.

First came the fragrances of his youth, the flowers and spices of his native Tunisia, the smells of cooking, citrus and Italy. Then came the aromas of life. His life. "The Mediterranean Sea is a part of me. It left a permanent mark on my childhood," he said, "just like the color blue, that strong presence of water and the sea in my life. All of my senses are captivated by the sun, the sand and the sky. These are the odors I always try to pour into my fragrances. The colors too, all thrown together. Carnations, roses, jasmine and the atmosphere of the souks filled with aromas and spices." This sensory perception of life, faithfully reinterpreted after his death, has given rise to the women's fragrances *Couture, Oh La La, Eau Belle,* and *Azzaro Pour Elle,* the men's fragrances *Azzaro Pour Homme* and *Chrome*, and now *Azzaro Wanted...* making this brand of "parfums à sillage" an expression of French luxury inspired by couture and our collective memory.

Loris Azzaro always referred to his fragrances as "weapons of seduction." But while he championed a certain extravagance in his fashion designs, he extolled the virtues of simplicity in his olfactory creations. It was no doubt a means of creating stronger contrast with his views on elegance, which in his case often amounted to wearing only suits and crewneck sweaters.

Powerful in essence, composed with simple, understandable ingredients, almost all of which are of natural origin—a rarity in modern perfumery—an Azzaro perfume stands out in the general fog of fragrances. It is the fruit of a complex, human, and learned internal alchemy. Its strength resides in its identity, its gendered nature. Highly feminine women's fragrances and highly masculine men's fragrances that share the same limpidity, as illustrated by *Azzaro Pour Homme*, an archetypical men's fougère that paints the portrait of a slightly macho ladies' man who loves women and life. Same evocation of power and virility with *Chrome*, a musky aquatic scent tinged with citrusy bergamot, or *Azzaro Wanted,* a fresh woody spicy fragrance that intertwines vetiver, lemon and cardamom. There is thus not an ounce of ambiguity to these scents that make a strong social statement, and even fewer vague or complex notes, even if the various fragrances belong to very different olfactory families. On the contrary, the tones of the fragrances are clear, composed with ingredients of extremely high quality in simple but never simplistic combinations, offering hints of aniseed, lavender, amber, rose, frankincense, bergamot and cardamom...

There is no attempt at intellectualism in their formulation, no pretension or arrogance in the desired effects. But conversely, there is a generosity that evokes voluptuousness, sensuality and sharing, a reflection of the life the couturier lived to the full. Like their lingering trail of scent, all of these great classics have an enduring timelessness about them that transcends trends, fashion and the spirit of the day.

Each Azzaro fragrance is a pure dose of sunshine, brilliance, freshness, good humor and joy. A symphony of sparkling bubbles.

It is much like Mediterranean cuisine–solar, convivial and full of flavor–that simple and natural cuisine that Loris Azzaro also compared to the dresses he designed.

AN ECHO OF COUTURE

The first women's fragrance, *Couture,* a bouquet of chypre and woody notes blended with aldehyde accords, was launched in 1975, nine years after the fashion label's founding. Composed by Jean Martel, the scent was rebaptized years later as *Azzaro Couture.* "My fragrance has to resemble my dresses," said Loris. "It has to work with a woman to her advantage. I know just how strong the erotic power of perfume can be." For the bottle, the couturier drew inspiration from a perfume vaporizer from the 1930s that Michelle chanced upon on one of her many trips to the flea market. As with any olfactory creation, the container was just as important as the contents, and so the design was entrusted to renowned bottle creator Pierre Dinand, who worked on an architectural shape of rings in homage to the *Trois Anneaux* dress. An elegant, intriguing, and graphic portrayal of couture and fragrance in perfect symbiosis, the bottle was later exhibited at the Museum of Modern Art in New York.

Success did not come with this first foray into the oh-so unpredictable world of women's perfumery, but with a men's eau de toilette, *Azzaro Pour Homme,* which quickly shot to international stardom. Loris liked to describe it as "a men's fragrance that women dream about."

Created by noses Gérard Anthony and Gerrit van Logchem, *Azzaro Pour Homme* was launched in 1978, the result of an encounter a year earlier between Richard Wirtz, a German manufacturer of toiletries and fragrances (notably the famous *Tabac Original,* a best-seller in Germany) and Loris Azzaro, the extraverted, flamboyant poet who made dresses for celebrities. But although the two men were opposed in every way, their fruitful discussions led to the creation of

a world-renowned fragrance that remains highly popular in Europe and Latin America to this day. The woody aromatic fougère no doubt owes this success to its rich formulation—over 320 raw materials to symbolize this tenderly macho but above all meridional fragrance with an exquisite amber color. Star anise is teamed with basil and lemon to provide a solar quality; a blend of bergamot, lavender, neroli, geranium and oak moss is used as an expression of seduction while patchouli, vetiver, sandalwood and cistus labdanum convey intensity. Another key to its success is the bottle, with its hexagonal lines and beveled edges. A stylistic feat by Pierre Dinand that would undergo slight changes over the years.

The elegant and sensual eau de toilette had another claim to fame: its memorable slogan, "men who love women who love men." The phrase just might carry a subliminal message like a harbinger of the life the couturier would later share with his wife Michelle and Reinhard Luthier, the story of two men and one woman. "Being seductive is important," said the couturier for the launch of the eau de toilette. "Perfume is an essential weapon of seduction. Without it, I don't think any personality is truly complete."

In 2014, Azzaro created a new olfactory opus, *Azzaro Pour Elle,* exploring the feminine face of Azzaro seduction with a vision of women in tune with their time: "a woman who dares" and who knows what she wants… To convey the scent of this bold, glamorous and seductive new woman, the fragrance is characterized by a rather unusual duo of cardamom and rose. The gleaming facets of the bottle recall the mirrored walls of the boutique on Rue du Faubourg Saint-Honoré in Paris, just as the decorative strip between the bottle and the cap evokes the lamé, rhinestones and silver of couture.

ALCHEMY OF EMOTIONS

"Loris Azzaro associated *Azzaro Pour Homme* with the image of the life he led, thus the fragrance was created with an overdose of ingredients," points out Daphné de Saint Marceaux, International

PR Director for Azzaro fragrances from 1991 to 2008, a fashion industry veteran who has held previous positions with Estée Lauder, luxury jeweler Boucheron and *Vogue* magazine. "Fragrance is not natural. It alters our odor, our mood, our personality, in the same way that clothing transforms us," said the couturier. "Just as colors and materials can be used to embellish, odors can be incredibly enhancing. I'm fascinated by this alchemy, this highly personal encounter between people and their fragrance."

"The first time I met him, I was ten. It was in Saint-Tropez," continues Daphné de Saint Marceaux. "He made and sold little wood-beaded bags at the time. I saw him again later in the boutique of the Hôtel de la Ponche, an institution in Saint-Tropez. He was with Reinhard Luthier, they were both dressed in loud colors. At night, they would go out to New Jimmy's clad in shorts, a furry monkey coat, or ruffled pants, stomachs bared, Loris in turquoise, Reinhard in mauve. It was all a form of provocation, true, but it was good-natured provocation. Those were the seventies, an era known for its parties and Loris's were legendary, particularly one at Chez Régine, *Une fois à Hollywood*. The three of them rolled up in a green convertible. Michelle was wearing a sequined dress."

The young PR manager quickly became close with the couturier, and she was often the one he showed his sketches to first. She played a diplomatic role, serving as the link between fragrance and couture. She organized last-minute lunches, meetings with all of the international press offices, and travel arrangements for the launches that Loris Azzaro always came to. "He was quite curious about what was happening in olfactory creation," she continues, "but he was above all interested in the lives of the people he loved. He brought a sparkling glamour to the drabness of daily life, and did the same for his friends who stayed by him to the end of his days. Once he asked me to take off my necklace so he could add beads to it. Another time he made me an evening gown from the Rubelli satin drapes of the salon. The fabric was a beautiful cream background with a tiger motif. I felt like Scarlett O'Hara."

TRANSMITTING *A* LEGACY

A new ode to femininity came forth in 1984 with *Azzaro 9*, a bouquet of nine rare flowers, his lucky number. Three years later, the construction of the house in Djerba coincided with the birth of the couturier's grandson, Romain. The Tunisian island became a precious source of inspiration. "Djerba is the land of all odors," he said, "the salty freshness of the sea spray, the spices that cling to your skin and the jasmine and orange blossom hanging in the air. Here, the sheets are scented with petals and people walk around with a sprig of jasmine behind their ear to smell its fragrance all day long."

In 1993, a new creation *Oh La La* was launched. Serge Mansau drew inspiration from Venice to design the bottle, a nod to Michelle who was an avid collector of marquetry furniture from the city of canals. Composed by Nathalie Feisthauer, *Eau Belle* was released in 1995, "a fragrance with humor and wit," described the couturier. "Its bottle is very appealing. I love the way the bubbles sparkle in the Biot glass." 1995 was also a milestone for Azzaro fragrances, marking the year it was bought by Clarins. To celebrate the event, a big party was held in the penthouse apartment on Boulevard Suchet. *Chrome*, created in 1996, was a fresh new men's fragrance with citrus, aquatic, and woody notes that gave a new boost to the house. It was an extremely modern and fresh fragrance composed with a blend of the finest raw materials. The scent was entrusted to nose Gérard Haury, who played with dominant maté and bergamot notes set against a backdrop of sandalwood. With its square shape, names sculpted in the glass, and chevroned chrome cap, the bottle designed by Federico Restrepo is a stunning work of architectural asceticism. Another strong factor in *Chrome*'s success was the message of the fragrance, the father-son bond passed down through three generations. It was a theme dear to Loris Azzaro, who drew upon his close relationship with his grandson Romain for the creation of the fragrance. "I am a passionate grandfather," he

said. "Grandchildren are a godsend; with them, everything takes on deeper meaning. Their view of me keeps me young because they are incredibly demanding."

Chrome is thus the story of an instinctive bond, something abstract and indefinable that is the very essence of the fragrance itself. This ode to the impalpable filial love is found in ad campaigns that are, on the contrary, clear and highly aesthetic, with a beauty that carries the idea of transmission within it. They are shot in a setting bathed in sun and light, where the blue of the sea bleeds into the intensity of the sky. "I had a special relationship with my grandfather," tells Romain. "He's the one who raised me. I was nine when *Chrome* was launched. I often played with the bottles lying around the house. I liked to press my eye up against the glass and watch the world go by. There was something pure about the color of the bottle, the blue of the sea. There was a freshness about it too. My grandfather went several times a year to Djerba back then. When he was there, his eyes were filled with joy. I often went with him. Our relationship was very strong and unique in the history of a fragrance."

A LINGERING TRAIL, PERSONALITY, TIMELESSNESS

As with architecture, the fragrance and bottle share the same concern for sobriety, particularly with *Chrome* whose name and graphic style evoke the silver flashes of sunlight on the sea, a childhood memory of Loris Azzaro on the beach. "At sunset, the Mediterranean often takes on a metallic tone. The sea becomes a liquid metal, like chrome," he said. "I love everything that shines, like the coolness and warmth of silvery metals. The name *Chrome* came from there. The idea was to create a timeless and elegant fragrance, something beautiful, simple, very classic, something that transcends fashion and embodies a notion of timelessness. And there is nothing more difficult than making things simple." This visceral attachment to the Mediterranean is something Olivier Courtin-Clarins, managing director of Clarins, confirms: "Loris

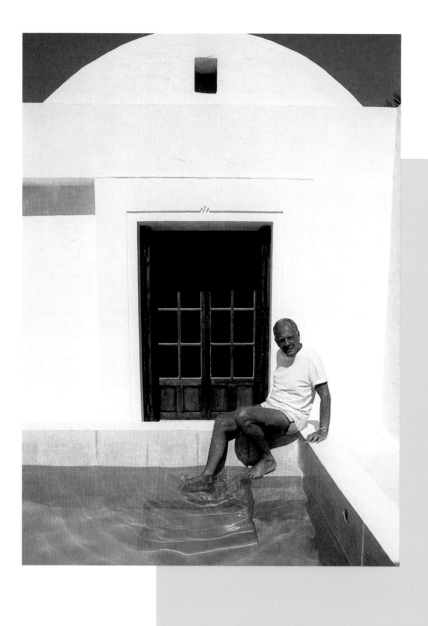

/ LORIS AZZARO AT
 HIS HOUSE IN DJERBA
CIRCA 1993.

Azzaro was charismatic and sensual. At his couture house, he greeted customers barefoot and recommended they wear nothing under their dresses. He could be extremely voluble at times, but I almost always saw him calm and collected. He loved to talk and be listened to. His voice was mesmerizing. For *Chrome*, he not only participated in the composition, but also helped direct the film and market the fragrance. It's one of the reasons the fragrance was so successful and still is today."

Christian Courtin-Clarins, president of the Clarins supervisory board, met Loris Azzaro in 1995. "We went to India together to be on the jury for the Miss India pageant. That was in 2000. I was immediately captivated by this man who made a name for himself updating dresses from the past that have never gone out of style. He created a whole world. And he shared the same values as our group: generosity, freedom and concern for humanity. His fragrances have personality, a lingering trail, a form of universality. Still today, the spirit of Loris lovers over everything we do."

Azzaro fragrances thus embrace an entire state of mind that consists of remaining true to the message of couture, rising above trends, fashion and the mood of the moment. But they also convey a subtle alchemy of freedom, provocation and chic irreverence, to rewrite the rules, transcend luxury and pass on the couturier's legacy without ever attempting to mimic or copy it.

This act of plunging fragrance into the present was also brilliantly reinterpreted by Vanessa Seward, who served as creative director for couture from 2002 to 2011. Composed in 1975 by Maurice Thiboud, *Couture* was renamed in 2008 as *Azzaro Couture*, "a fragrance made for seduction," described the couturier, "in the style of the dresses I design. To me, it's a fragrance of the night. An exceptional fragrance for exceptional moments." Vanessa Seward thus appropriated the fragrance and gave it a modern touch while staying true to its past. "When I started out with Loris Azzaro, he very quickly let me update his vintage dresses on the condition that I changed them only slightly," explains the stylist. "I proceeded the

same way with the new edition of *Azzaro Couture*. I approached this classic fragrance with respect for the label's roots and its couture tradition. And I developed the fragrance the way I reworked the dresses, as a guardian of this distinctive signature."

The stylist entrusted the fragrance to Aurélien Guichard, who simplified its olfactory structure to create a luminous scent. It is composed of five absolutes, a rarity in contemporary perfumery: mimosa, May rose, Italian iris, ambrette seed and galbanum.

The original black bottle was made white, transitioning from night to day. The Swarovski crystals, applied on the bottle by hand, recall the shimmering embroidery of evening gowns. Vanessa Seward chose Jemima Khan as the face of the fragrance, a loyal Azzaro customer, mother and ambassador for UNICEF. She was photographed wearing the 1974 *Trois Anneaux* dress embroidered with crystals, in the boutique on Rue du Faubourg Saint-Honoré.

GENEROUS AND SOLAR

The latest addition to the family is *Azzaro Wanted*. It pays a vibrant homage to the very personality of Loris Azzaro—a fragrant expression of his solar, generous, and flamboyant temperament. It is the reflection of a free, irresistible and somewhat high-rolling man who took his chances and always succeeded, a man whose values served more than ever as a guide for the creation of *Azzaro Wanted*. Two years of work went into the creation of this woody, citrus and spicy fragrance housed in a barrel-like bottle reminiscent of the inner workings of a clock: "a true weapon of seduction," a metaphor Loris Azzaro himself often used to describe his fragrances.

"Some brands fired my dreams," tells Fabrice Pellegrin, the nose who concocted this fragrance of desire and had already worked on *Azzaro Pour Elle* with Nathalie Lorson in 2014. "*Azzaro Pour Homme* always reminded me of my father's scent, the smell of a modern man, something very masculine and very sophisticated at the same time." The predominance of woody and spicy notes in *Azzaro Wanted* is

the fruit of a clever blend of cardamom, ginger, Tonka bean and leather-tinged essence of cade, the shrub bearing brown and orange fruit that grows in the Mediterranean garrigue. A sensual and solar olfactory symphony that celebrates timelessness and an unfailing love of life.

In fragrance as with fashion, the spirit of Loris is imbued in the creation... The brand "that celebrates life" is embarking on a new era with flamboyant expression in keeping with the core values upheld by the bold, pleasure-seeking, generous, seductive, free to choose and live life in his own way: Loris Azzaro.

AZZARO COUTURE

Couture is Azzaro's first women's fragrance – a bouquet of woody, *chypre* notes mixed with aldehyde accords. It comes showcased in an elegant bottle (once exhibited at NYC's MoMA) featuring intriguing graphics that perfectly straddle the line between couture and perfume. The scent was first launched in 1975, nine years after the creation of the brand itself, and eventually took the name *Azzaro Couture*.

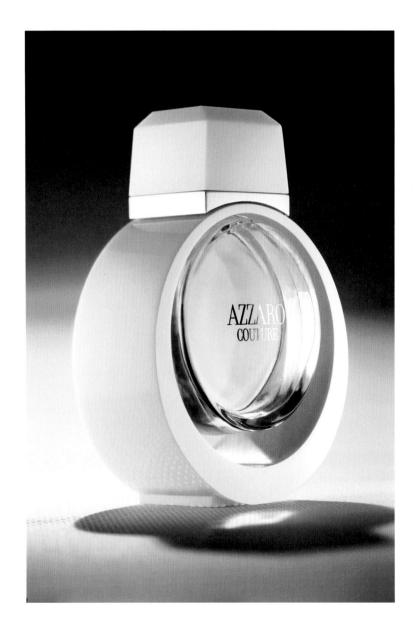

RIGHT: JEMIMA KHAN WEARING SWAROVSKI CRYSTAL EMBROIDERED *PARFUM* DRESS (VANESSA SEWARD FOR AZZARO, SPRING/SUMMER 2004) TO MARK THE NEW EDITION OF *AZZARO COUTURE* PERFUME, 2008.

EACH AZZARO FRAGRANCE
IS *A* PURE DOSE
OF SUNSHINE, BRILLIANCE,
FRESHNESS, GOOD HUMOR
AND JOY. *A* SYMPHONY
OF SPARKLING BUBBLES.
IT IS MUCH LIKE
MEDITERRANEAN CUISINE
–SOLAR, CONVIVIAL,
AND FULL OF FLAVOR–
THAT SIMPLE AND NATURAL
CUISINE THAT LORIS *AZZARO*
ALSO COMPARED TO
THE DRESSES HE DESIGNED.

ADVERTISING CAMPAIGN
FOR THE FIRST *AZZARO*
PERFUME LAUNCHED IN 1975
– A *CHYPRE* FRAGRANCE
MODERNIZED IN 2008 BY
VANESSE SEWARD.

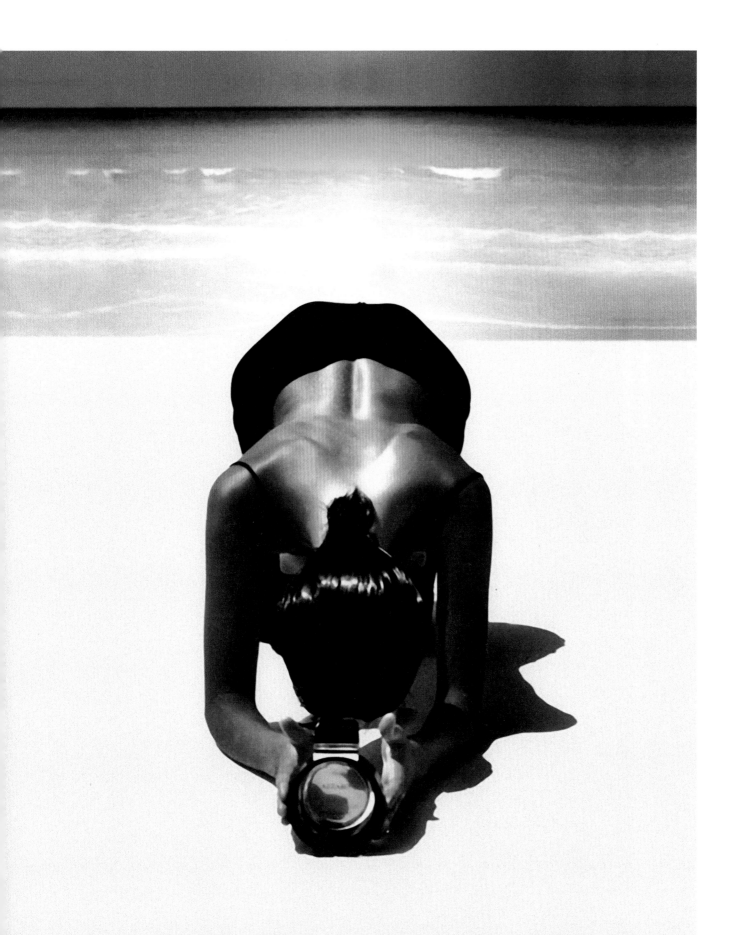

CHROME

Chrome, created in 1996, is a fresh, masculine
eau de toilette with citrus and aquatic notes:
*"a timeless and very elegant fragrance, something
new and simple... and there is nothing more difficult
than making things simple,"* Loris said. The fragrance
conveys a strong message of the father-son bond
passed down through generations, a theme
the couturier held dear.

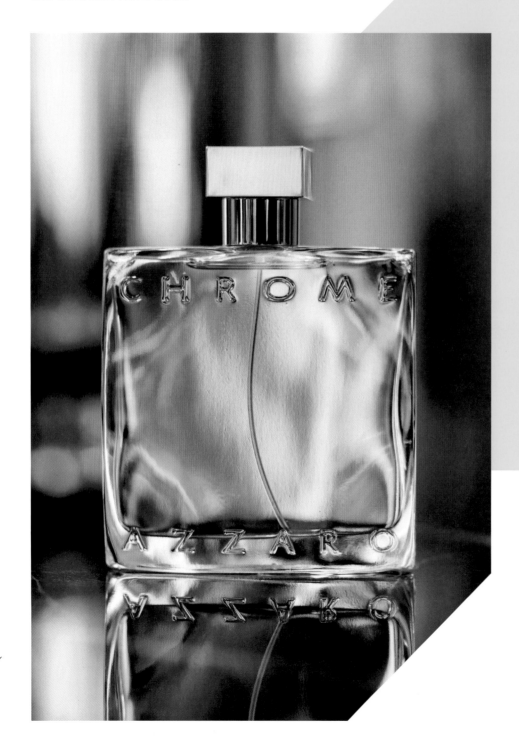

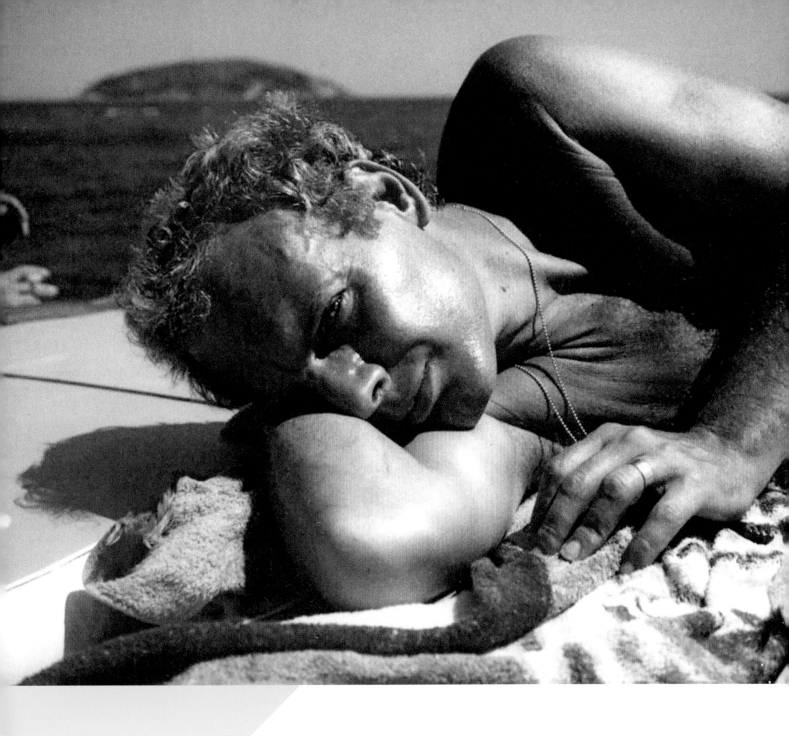

LORIS AZZARO ABOARD
HIS RIVA IN SAINT TROPEZ.

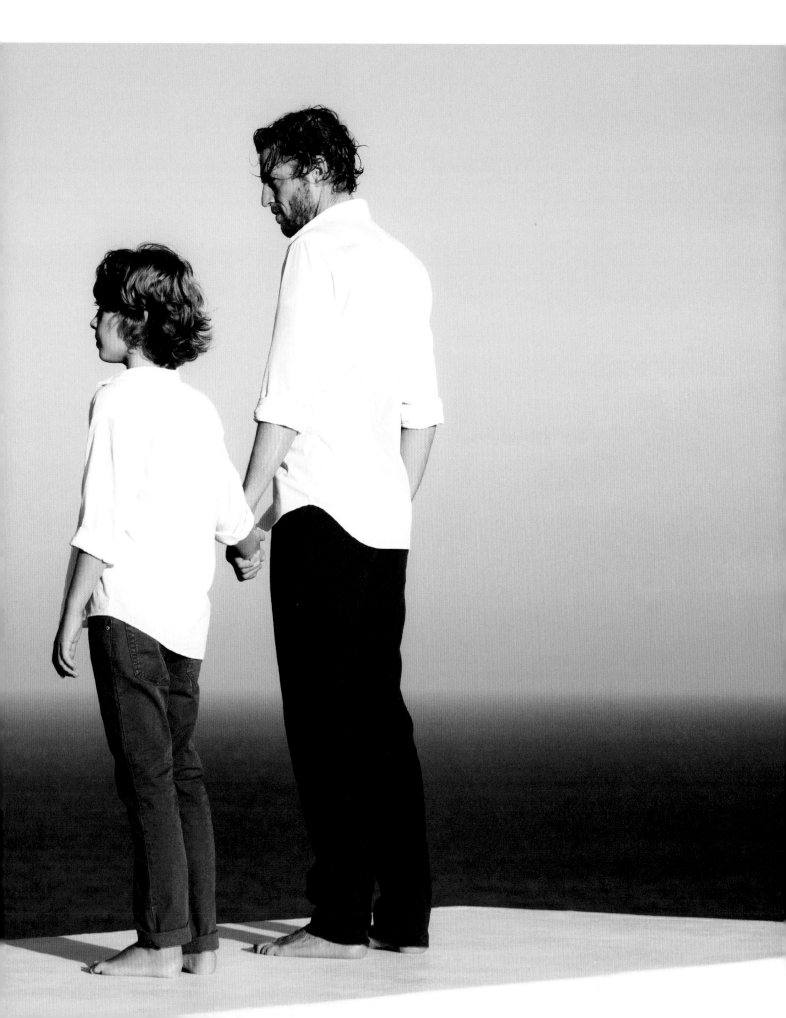

AZZARO
POUR HOMME

The iconic scent of masculine seduction...
Launched in 1978 *Azzaro pour Homme* now
enjoys almost legendary appeal in the world
of men's fragrances. Richly aromatic
with woody notes of wild fern and a warm,
amber-like color, *Azzaro pour Homme*
embodies the allure of men who love
life and women.

RIGHT: LORIS AZZARO
IN DJERBA.

MY FRAGRANCE HAS TO RESEMBLE MY DRESSES, IT HAS TO WORK WITH A WOMAN TO HER ADVANTAGE. I KNOW JUST HOW STRONG THE EROTIC POWER OF PERFUME CAN BE.

Loris Azzaro

LORIS AZZARO
PHOTOGRAPHED
IN ROME WITH A MODEL
WEARING A FEATHER-TRIMMED
CHIFFON CAPE OVERLAY.

AZZARO WANTED

The latest addition to the family is *Azzaro Wanted*, a fragrance "of desire" that pays homage to the vibrant personality of Loris Azzaro and to his solar, generous and flamboyant temperament. The predominance of its woody and spicy notes is the fruit of a clever blend of cardamom, ginger, Tonka bean and essence of cade, the shrub that grows in the garrigue and evokes the couturier's beloved Mediterranean.

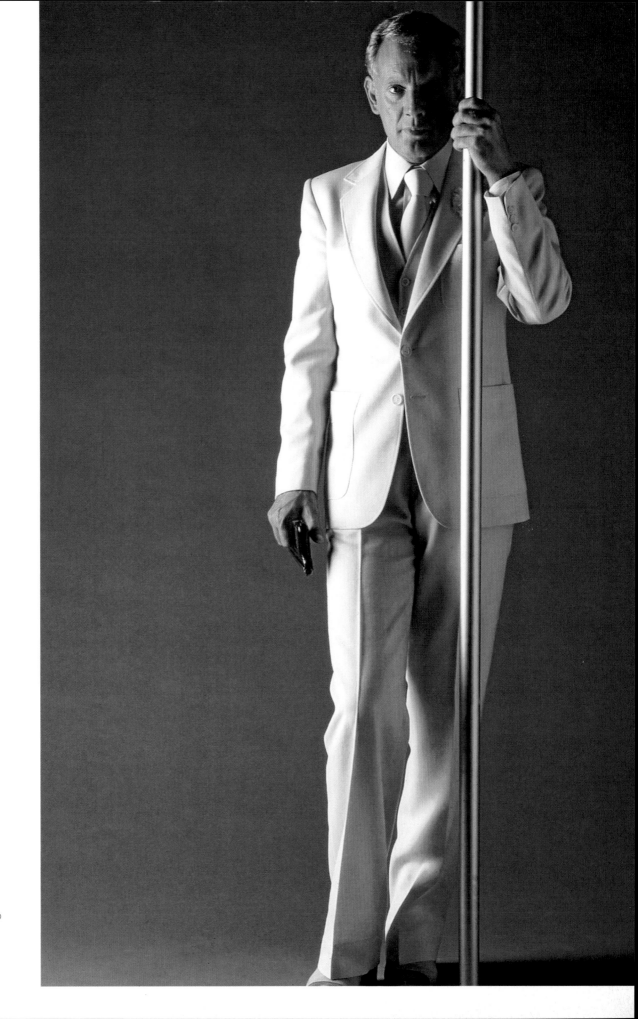

PERFUME IS AN ESSENTIAL WEAPON OF SEDUCTION. WITHOUT IT, I DON'T THINK ANY PERSONALITY IS TRULY COMPLETE.

Loris Azzaro

AZZARO

TODAY'S STUNNERS

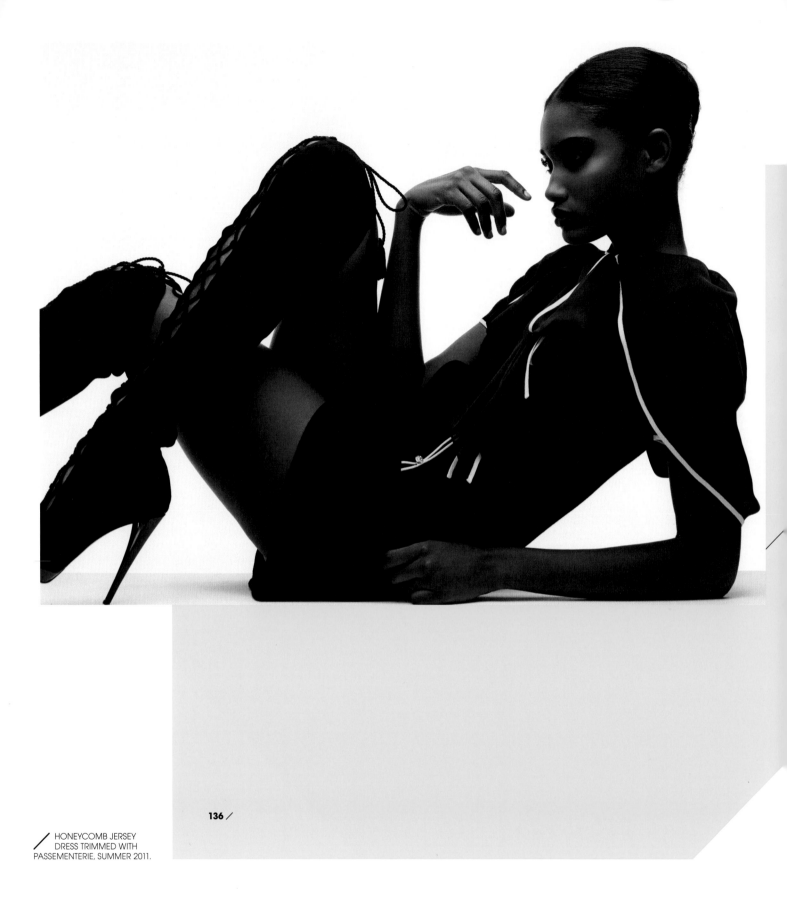

136 /

With the coming of the 2000s, the Azzaro woman has kept pace with changing society. She has become (slightly) calmer, goes out a little less at night or opts for less formal attire, without losing any of her sophistication or sensuality. Friends and celebrities remain as loyal as ever to the couture house, however, making regular visits to the boutique on Rue du Faubourg Saint-Honoré to find the sheaths and femme-fatal dresses that make them more beautiful than any other. The couture salon is still imbued with the same poetry, even if the parties of yore are dispersed in misty memories. When Loris Azzaro passed away in 2003, his assistant Vanessa Seward had the difficult task of perpetuating the couturier's legacy, a challenge she met with flying panache until 2011. Duo Arnaud Maillard and Alvaro Castejón relaunched the Couture lines in 2014, before the arrival of young fashion genius Maxime Simoëns in 2017, the year of the house's fiftieth anniversary.

2002 TO 2011, *VANESSA SEWARD*, THE PAST PERFECT

The arrival of Vanessa Seward, an Argentinian-born French-based designer hired by Michelle Azzaro as her assistant, inaugurated a new era, taking up the torch from Catherine Azzaro who designed the collections with her father in the 2000s. "Vanessa Seward was able to breathe new life into the house, readapting the style without erasing its identity," confirms Dominique Salmon. "She brought quality, refinement, a more modern chic and a certain amount of freshness. She gave of herself, with a great deal of modesty."
After graduating from the Studio Berçot design school, the young stylist started out with Chanel, where she stayed for nine years, followed by two years working with Tom Ford in the accessories department of Yves Saint Laurent. But this elegant, discreet, visionary young woman was no stranger to the world of fashion, for she had lived for many years on Rue du Cirque in the 8th arrondissement of Paris, not far from Rue du Faubourg Saint-Honoré, and thus the Loris Azzaro boutique where her mother worked as a salesperson. "I was fascinated by this little couture house that made only evening gowns," she says. "Each dress magnified what was most beautiful about a woman and made her extremely seductive. The brand was nothing like the major labels of the time with all their media and sales hype—it exuded a luxury and elegance of its own. Even though his glory years were behind him, Loris Azzaro continued to dress a number of actresses, such as Arielle Dombasle and Vanessa Paradis, as he had before with Dalida, Sophia Loren and Marisa Berenson. He saw women as vestal beauties, drawing inspiration from Hollywood style and 1930s fashion to exalt them. He gave pride of place to sensuality, but a subtle sensuality, never vulgar or outrageous. The Azzaro style was a potent mix of all this, but it was above all the threesome that the couturier formed with Reinhard Luthier and his wife Michelle, an explosive and awesome threesome."
When he regained control of the creative direction of the house, Loris Azzaro kept only the young genius from the previous team.

She threw herself into the adventure with passion, traveled and represented the couturier everywhere, persuading him to focus back on the dresses from his finest years, and to go with her to see what was being done elsewhere, something that bored him. "Fashion doesn't matter, only style does," he professed.

"Even though he was extremely exhausted at that time, his main concern was to protect his label and his employees," confirms Vanessa Seward. "He could be as endearing as he was temperamental, but he hated to hurt people unnecessarily. He made me cry once, but it affected him so much that it never happened again. He was theatrical, he had style, he knew how to place his voice. He loved to seduce and make sure that women were seductive too. Contrary to what one might think, he wasn't riveted on himself." Attentive to the past while delicately leaving her mark, the stylist followed the main lines that built the reputation of the house: flowing fabrics, jersey draped in the style of Madame Grès, bejeweled dresses, embroidered dresses, sequins, chain-link sweaters and metallic lamés. With a flair nurtured by her experience and a more modern vision of the silhouette, she combed the house archives for designs like the *Liz* and *Lyre* dresses that she then updated, or the *Trois Anneaux* that she reworked in the atelier with the head seamstress Josy—"a remarkable woman"—and would become a bestseller, even though the original dress was not. The dawn of this new millennium was marked by a vintage revival, particularly in Hollywood where A-listers hit the red carpet in gowns from those oft-copied years.

I TRUST US

"Use your past work as inspiration for new dresses," whispered the young woman in the couturier's ear as she created four new designs of her own and launched the trend of white and crystal. Together they worked magic and in 2003 the house released twenty new creations that didn't fully appeal to the eternally dissatisfied Loris

Azzaro. So Vanessa Seward invited Carine Roitfeld, editor-in-chief of *Vogue Paris*, to come see the collection. Absolutely thrilled, she devoted six pages of her magazine to it.

"I trust us," Loris Azzaro once said to the stylist who had called him to discuss the boutique renovation project entrusted to interior designers Dorothée Boissier and Patrick Gilles. "If there's one thing I've retained from my time with him, it's that sentence," she confides. "Those three words are without a doubt what pushed me to continue."

Riding this new wave of media attention, Vanessa Seward took up his fight as the couturier passed away the day after their spread in *Vogue* was released. While the first collection in her name remained true to the archives, the young woman would put more of her own spin on the collections to follow. And it worked. As did the ad campaigns that she managed at the same time, propelling the brand into a new era of modernity. "Vanessa Seward did a very subtle job," confirms Béatrice Azzaro. "She managed to retain my father's spirit while adding an English touch. She created haute couture without it being haute couture. A class act!" "I could not have done better," adds Catherine Azzaro. "She was able to revive the spirit of our fashion house."

Taking care to respect the spirit of the couturier right down to the décor, the young stylist also saw to the atmosphere in the recently renovated boutique. She transformed it into a sophisticated little salon with soft music playing in the background, a place where customers love to spend time and reconnect with the soul of the man who is there no longer.

"I think of him often," concludes the young woman who left the house in 2011 to found her own label in Saint-Germain-des-Prés. "I drop by the boutique from time to time and I'm still in close contact with Dominique Salmon. All of the knowledge I acquired there still serves me today."

THE FIFTIETH ANNIVERSARY SHOW

To celebrate this anniversary of a brand that has sailed through the years without aging, muses and socialites Bianca Brandolini d'Adda and Eugénie Niarchos pored over the archives to revisit the most iconic designs, such as the *Trois Anneaux* or *Cœur* dresses, which they then passed on to the studio and ateliers to be updated. The two women share a love of fashion and the house of Azzaro, as well as films and music from the 1970s, the songs of Diana Ross... When she was a little girl, Bianca Brandolini d'Adda discovered the designer's dresses in her mother's closet, and then in the pages of *Vogue Paris*. Since then, she has been an avid collector of vintage Azzaro pieces. "I love the steadfast vision this couture house holds of women, identical to the vision Loris Azzaro had fifty years ago: a sensual, elegant, strong, and slightly provocative woman who is not afraid to flaunt her femininity and does not want to dress like a concept."

Eugénie Niarchos, on the other hand, received her first Azzaro dress for her nineteenth birthday. She too is no stranger to the house, for ten years ago she collaborated on two projects for the jewelry line under the creative direction of Vanessa Seward. A total fan of the early years, the young woman still finds today what had appealed to women so strongly in the 1970s, that timeless mix of glamour, fantasy and elegance. "The collection is above all made for women who want to feel like a woman, while having fun and being sexy." The timeless and captivating scent of festive and carefree glamour pervades each of the dresses that are as much a celebration of femininity as ever, with silhouettes that mix transparency and fluidity and structured cuts that hold true to the original codes of style. For this new collection presented during the Haute Couture fashion week in January 2017, plunging necklines front or back, the gleam of custom embroidery and a mass of chains and fringes launched a revival of the Azzaro style with its drapery, gathers, stretch lamés and flowing mesh tunics. "The black sheath dress laced at the side is what I would choose for a red carpet event as an

alternative to the long gown," confirms Bianca Brandolini d'Adda, "and the silk pajamas for a party. But I would opt for the revisited *Baba* dress for a casual-chic party or a holiday lunch by the water."

MAXIME SIMOËNS, THE FUTURE PERFECT

In March 2017, Maxime Simoëns was appointed as the brand's artistic director by CEO Gabriel de Linage, who saw in the poised and discreet 32-year-old designer a worthy successor to the couturier. His previous work already showed a real affinity with the wardrobe of Loris Azzaro, the same penchant for structured, architectural and graphic lines, for embroidery, flowing fabrics, contrasts between matte and glossy, sheer and opaque, optical illusions. And a shared desire to make women simply beautiful, to highlight their shape without laying them bare, to render them sexy and sophisticated.

While his first loves were the theater and film directing, he was quickly disappointed. "I thought they were going to teach me how to tell stories," he admits. But Maxime Simoëns would end up telling his stories through fashion, a much more hands-on and concrete means of expression than the stage and abstract texts.

After graduating at the top of his class from the Chambre Syndicale de la Couture Parisienne in 2006, he pursued his apprenticeship with Elie Saab, Jean-Paul Gaultier, Christian Dior and Balenciaga, where he took a particular interest in embroidery and prints. He made a strong impression at the Hyères Festival in 2008 and the next year founded his fashion house on Rue Montmartre in Paris. He joined the official Haute Couture schedule in 2011 and enjoyed immediate success. Like Loris Azzaro in his day, the young couturier became the go-to designer for the stars. Singer Beyoncé fell under his spell and chose a purple dress for the cover of her fourth album, while American actress Blake Lively was spotted wearing one of his jackets for the television series *Gossip Girl*. Emma Watson, Kylie Minogue, Beth Ditto, Mélanie Laurent, Juliette Binoche,

Carla Bruni, and even Léa Seydoux for her Palme d'or in Cannes, all snatched up his designs that are steeped in an era, a blend of poetry and modernity. He began receiving calls from the big couture houses, notably Léonard where he served as artistic director from 2011 to 2012. Expected to take over Dior artistic direction after the departure of John Galliano, he would forge his path with his own name and style.

While Loris Azzaro saw women as exuberant creatures of the night, Maxime Simoëns sees them as beauties of the day, women as sexy, bold and independent as ever, who command respect without being pushy. Terribly feminine and seductive, as if it were nothing. To convey this woman who walks the line of provocation without sinking into vulgarity, the fabrics adhere to the sensual diktat of the former master of the house without ever parodying it. Muslin, jersey, sequins, embroidery and P.V.C.—a material that the young stylist had already worked into his personal collections, thus reflecting Loris Azzaro's taste for atypical combinations in some of his creations, like the curtain rings of the legendary dress on the *Elle* cover in 1968, or the liquid polyester transformed into teardrops in the mid-1970s. "It seemed paramount to me, before sketching the slightest design, to delve into the history of the house, in order to respect its soul," states the new artistic director, "to subtly distill the epicurean vein of Loris Azzaro, his love of life, his flamboyant and non-conformist nature and his taste for paradoxes." Maxime Simoëns has also taken up the men's lines that were created by Loris Azzaro in 1977 and developed under licenses. Attention to detail and respect for the house style updated with flawless cuts have revived the chic spirit that prevailed in Loris Azzaro's men's wear, alter ego of the uninhibited Azzaro woman, mixing Mediterranean *bella vit*à and breezy French elegance. The spirit of Loris still watches over the house, now more than ever before.

THE VANESSA
SEWARD YEARS

From 2002 to 2011, stylist Vanessa Seward took over
as creative director of the house, modernizing
and simplifying the designs while giving them a more chic
edge that remained true to the spirit of the couturier.
"When I started out with Loris Azzaro, he very quickly
let me update his vintage dresses on the condition that
I changed them only slightly," she explains.

/ VISCOSE JERSEY,
SWAROSVKI CRYSTAL-
EMBROIDERED *PARFUM DRESS*
(*TROIS ANNEAUX*). VANESSA
SEWARD FOR AZZARO,
SUMMER 2004.

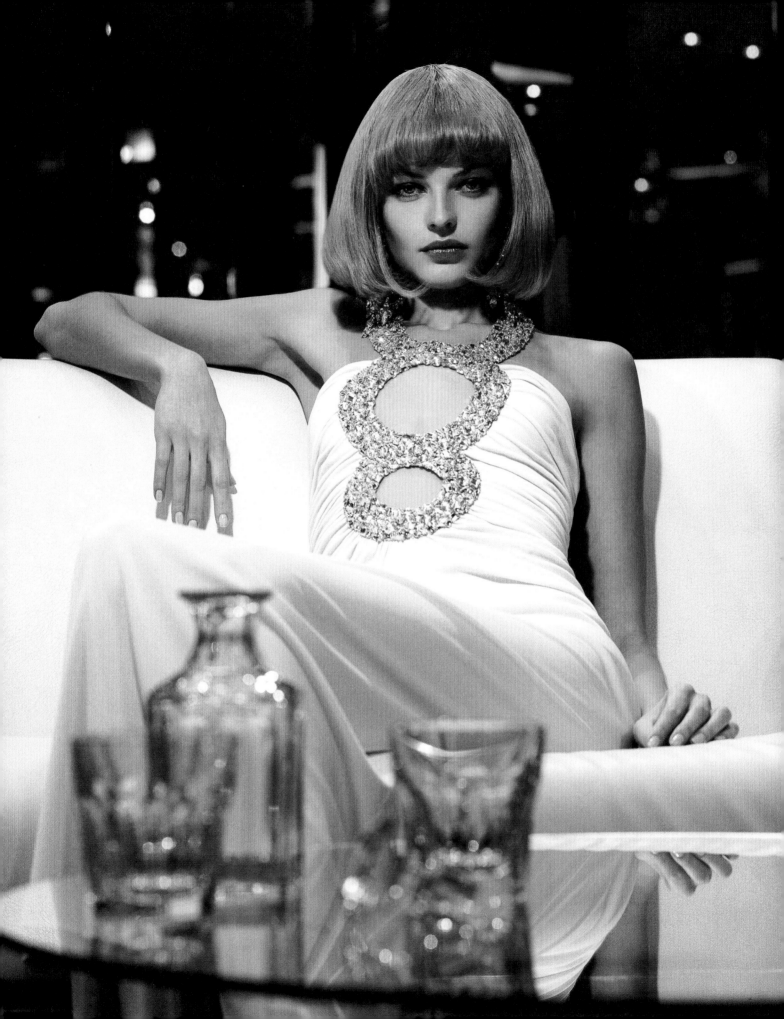

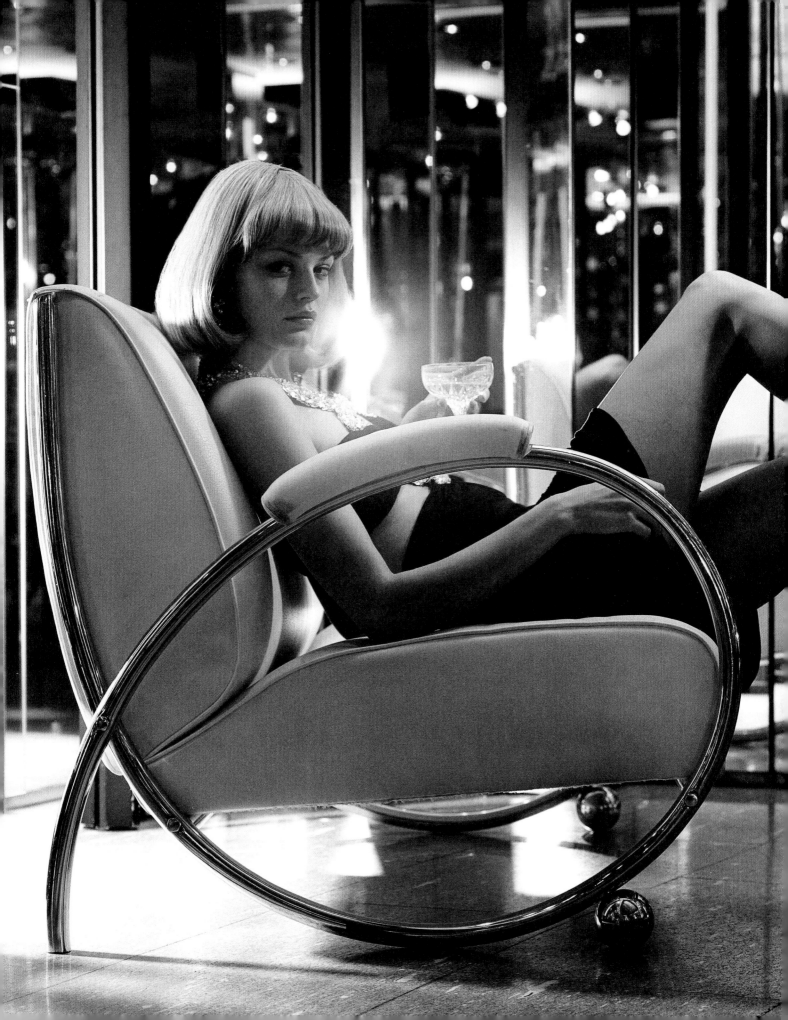

VISCOSE JERSEY
SWAROSVKI CRYSTAL-
EMBROIDERED *Princesse*
DRESS. VANESSA SEWARD
FOR AZZARO, SUMMER 2004.

BEHIND THE JEWEL DRESSES, THE DRAPING FABRICS, THE SHIFTS AND THE LAMÉS, HE STROVE ABOVE ALL TO INVENT A NEW IDEA OF WHAT IT WAS TO BE A WOMAN, AND SHE LATCHED ONTO THE PHENOMENON READILY, WEARING HIS CREATIONS AGAINST HER SKIN. MOST OF THE DRESSES ACTUALLY REVEALED SOME SKIN. THEY HAD A GENTLE, ELEGANT AND JOYFUL PROVOCATION ABOUT THEM.

Olivier Saillard

VISCOSE JERSEY *POÈME* DRESS (VANESSA SEWARD FOR AZZARO, SUMMER 2004)

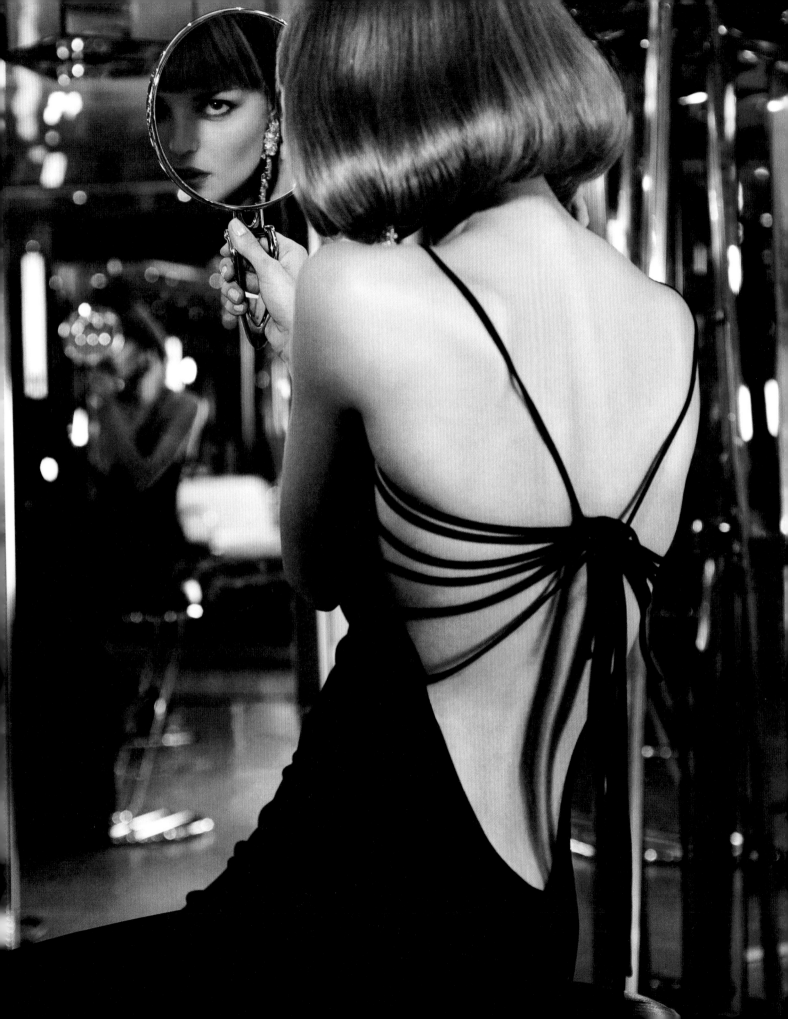

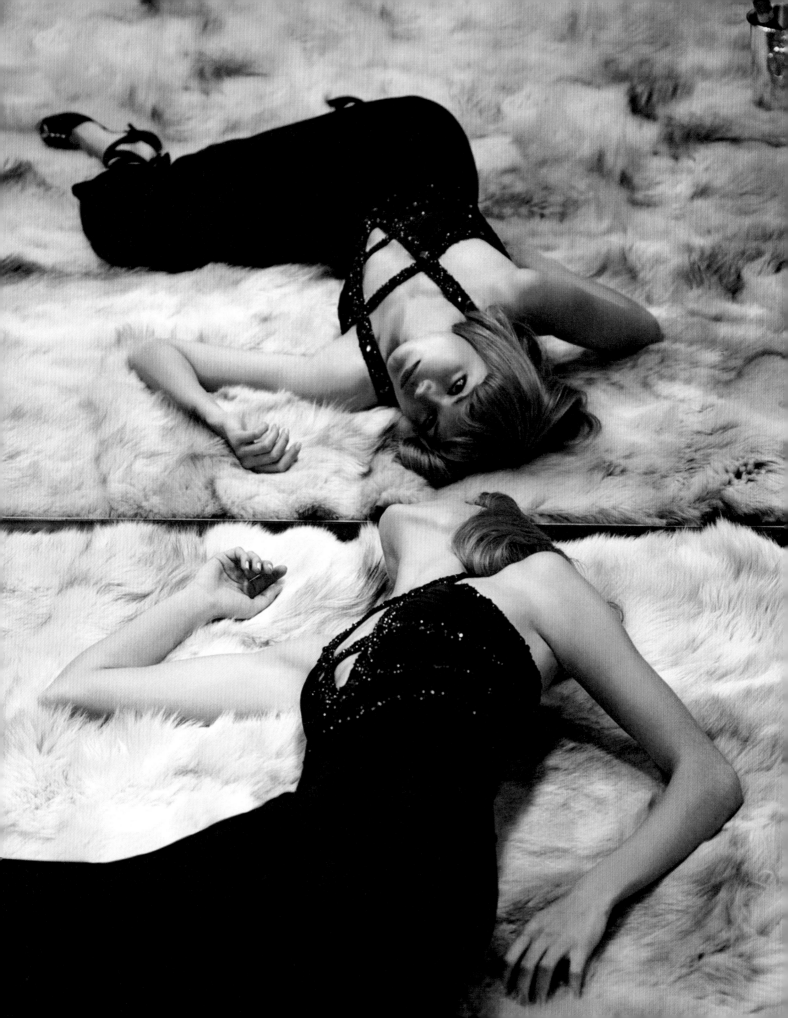

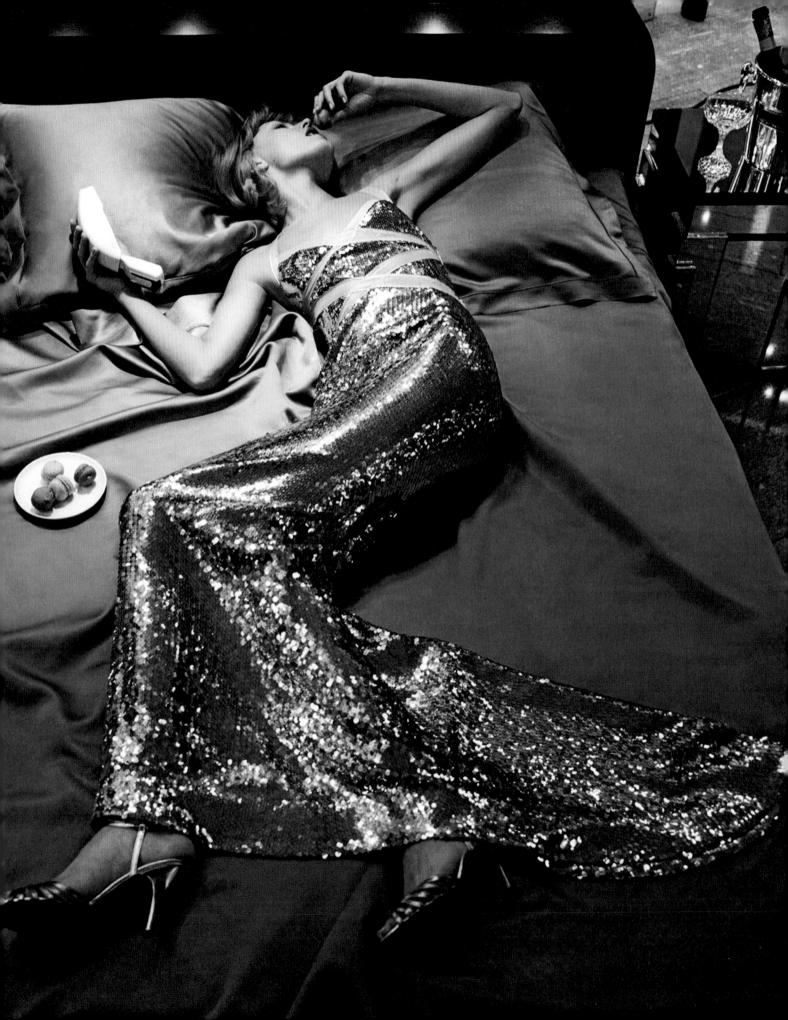

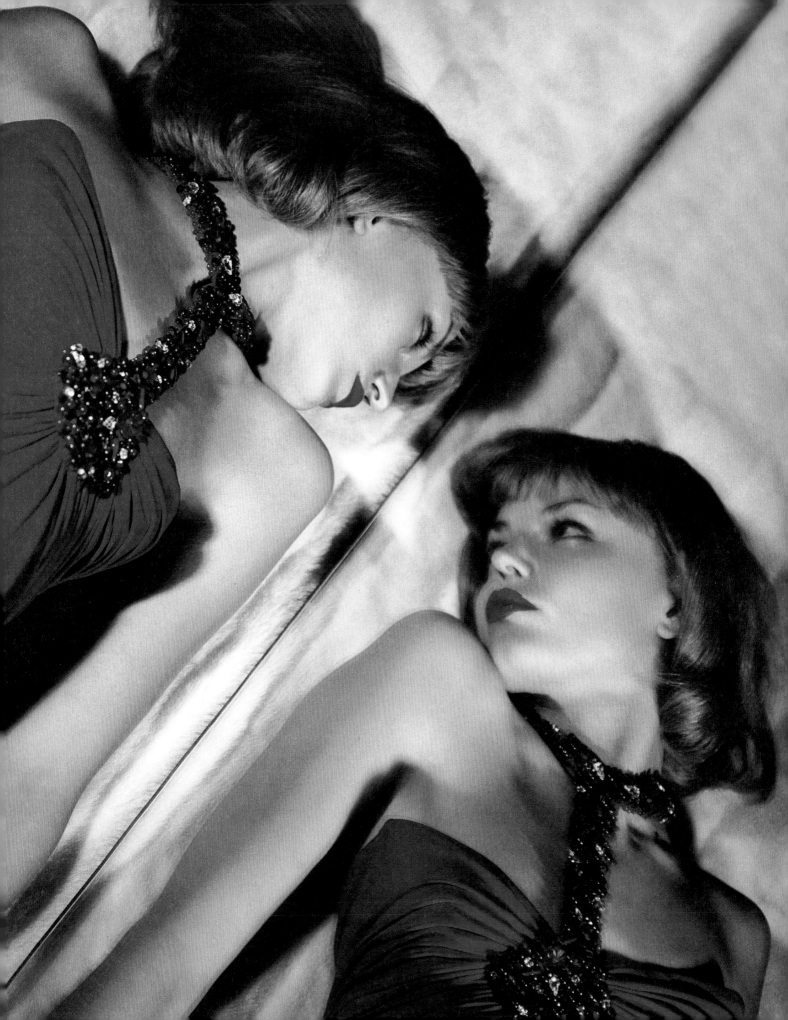

LORIS AZZARO SAW WOMEN
AS VESTAL BEAUTIES,
DRAWING INSPIRATION FROM
HOLLYWOOD STYLE AND
1930S FASHION TO EXALT
THEM. HE GAVE PRIDE OF
PLACE TO SENSUALITY, BUT
A SUBTLE SENSUALITY, NEVER
VULGAR OR OUTRAGEOUS.
THE AZZARO STYLE WAS
A POTENT MIX OF ALL THIS…

Vanessa Seward

/ *RIGHT*: VISCOSE JERSEY
DRAPE *PARFUM* DRESS.
VANESSA SEWARD FOR AZZARO,
SUMMER 2004.

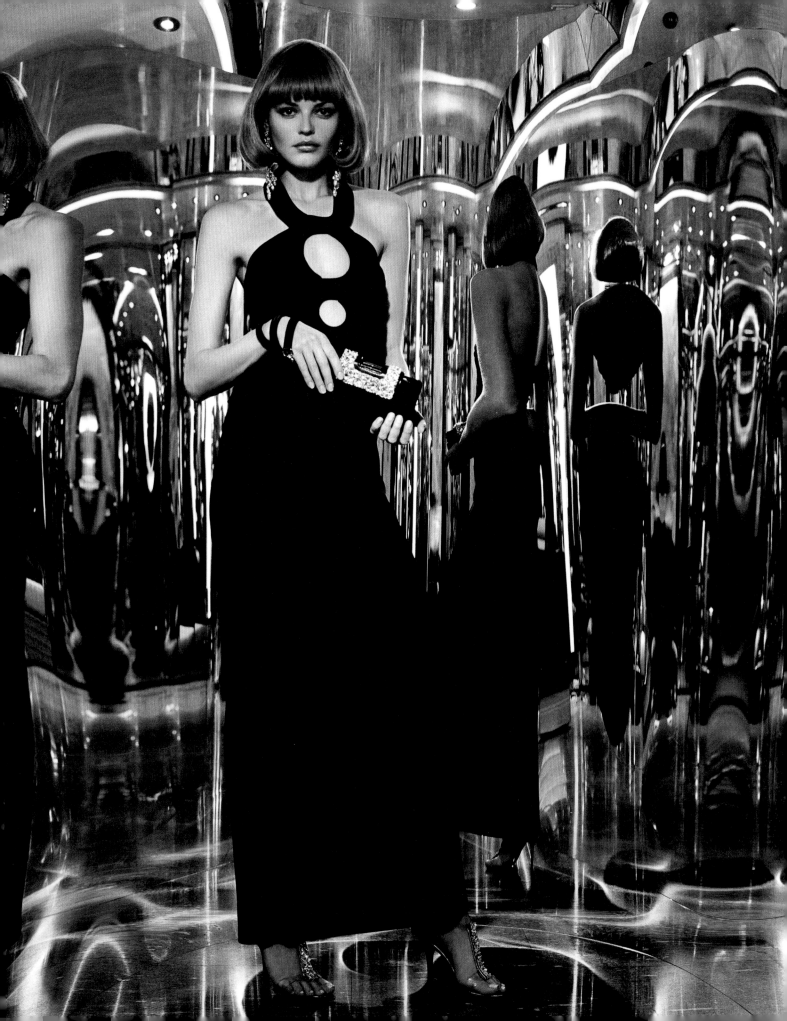

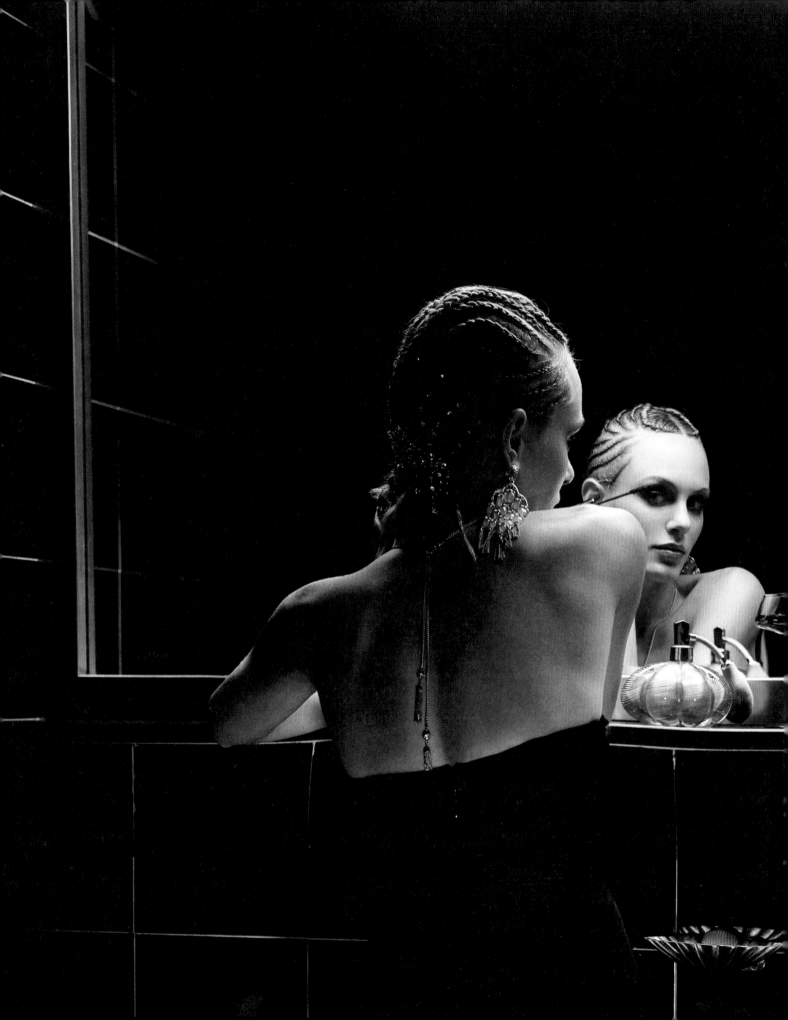

VISCOSE JERSEY DRAPED
BUSTIER *SCORPIOS* DRESS.
VANESSA SEWARD FOR AZZARO,
SUMMER 2005.

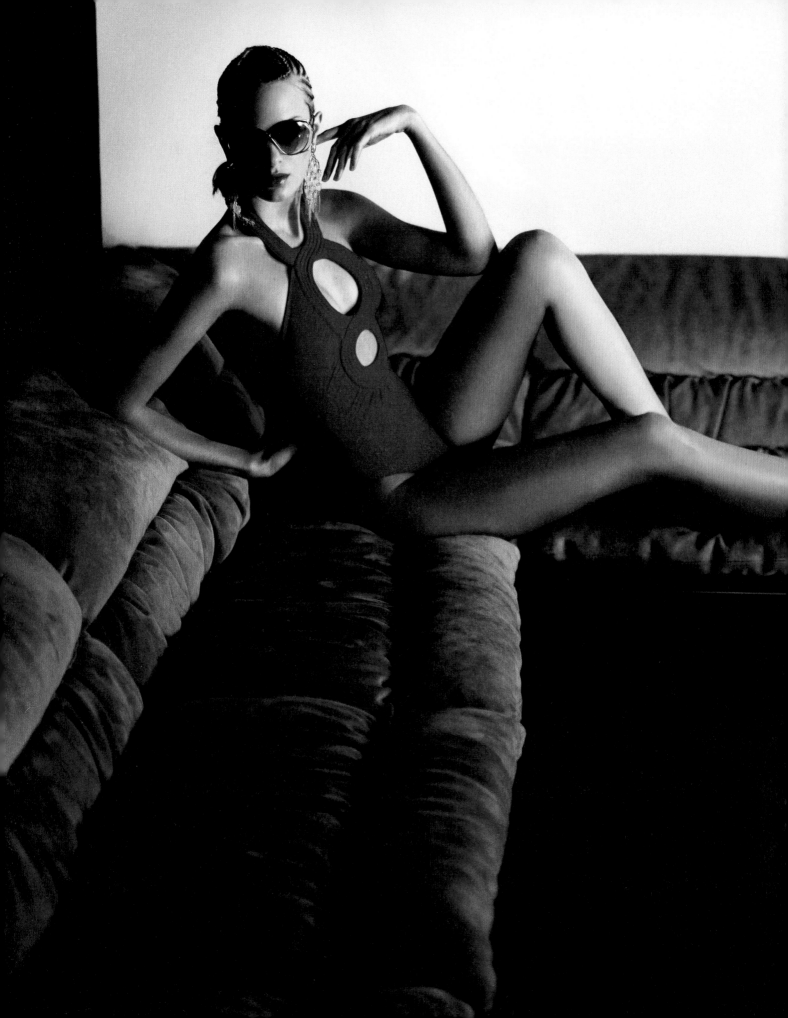

STRETCH JERSEY *SUMMER*
SWIMSUIT. VANESSA
SEWARD FOR AZZARO,
SUMMER 2005.

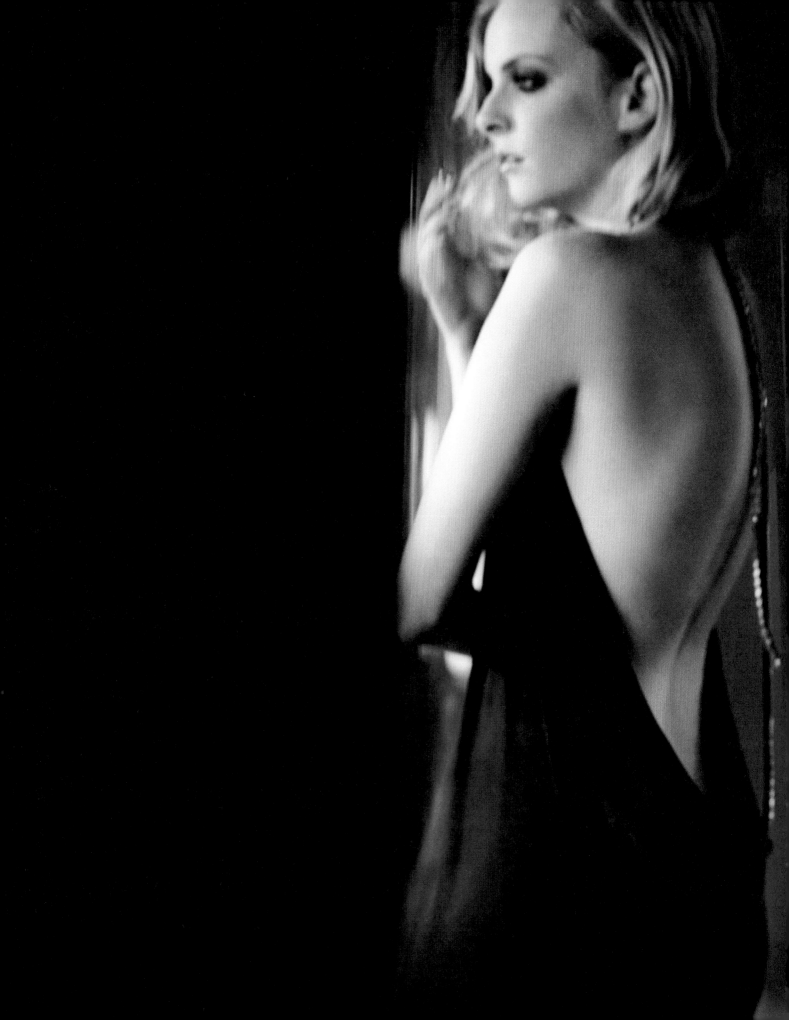

SILK JERSEY CRYSTAL-
EMBROIDERED *CARA*
DRESS. VANESSA SEWARD
FOR AZZARO, WINTER 2007.

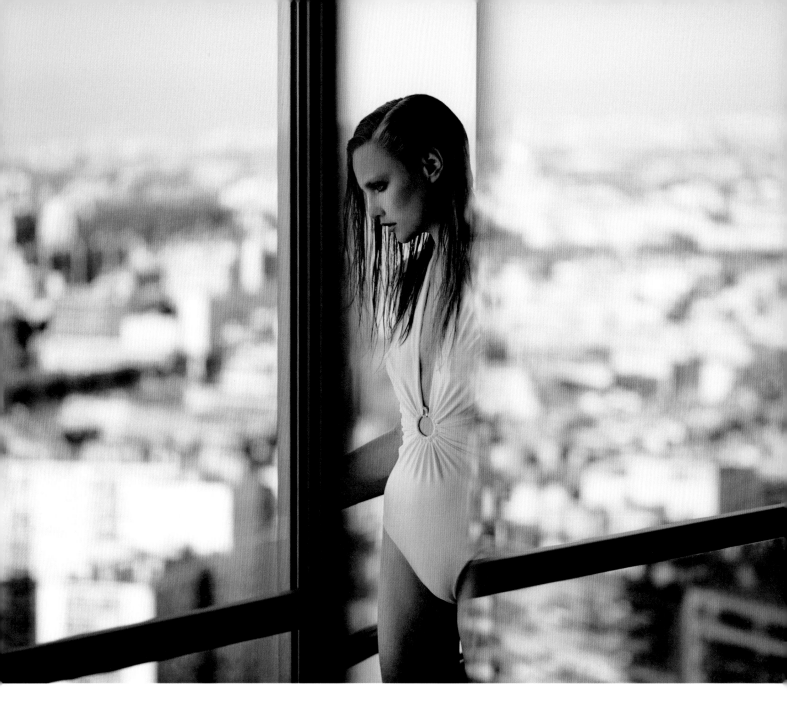

/ *DEAUVILLE* SWIMSUIT.
VANESSA SEWARD
FOR AZZARO, SUMMER 2008.

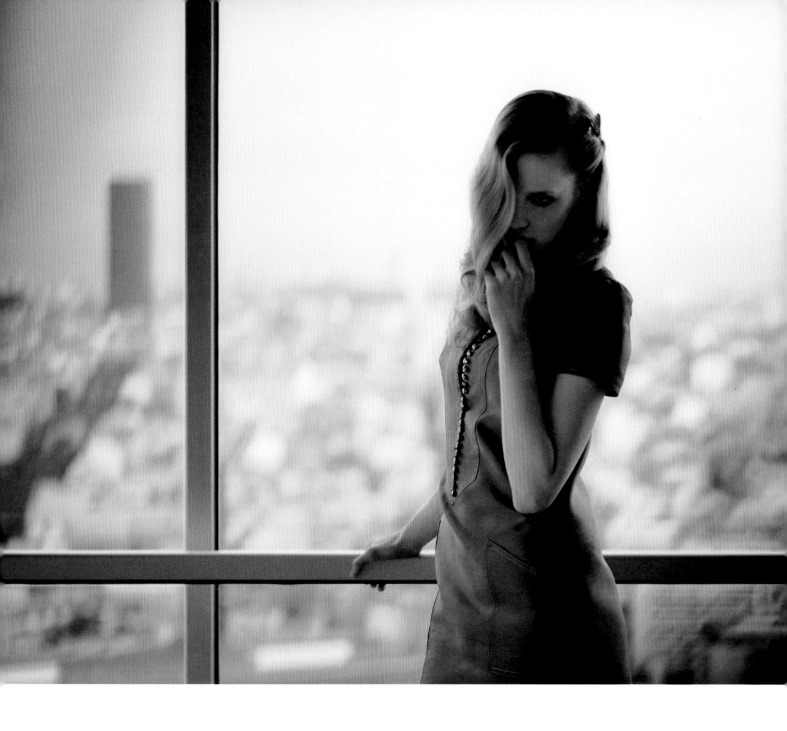

RAW SILK *DAMAS* DRESS
WITH CRYSTAL BUTTONS.
VANESSA SEWARD FOR AZZARO,
SUMMER 2008.

/ SLINKY CHARMEUSE *DIVINE*
DRESS WITH CRYSTAL
EMBROIDERY. VANESSA SEWARD
FOR AZZARO, SUMMER 2009.

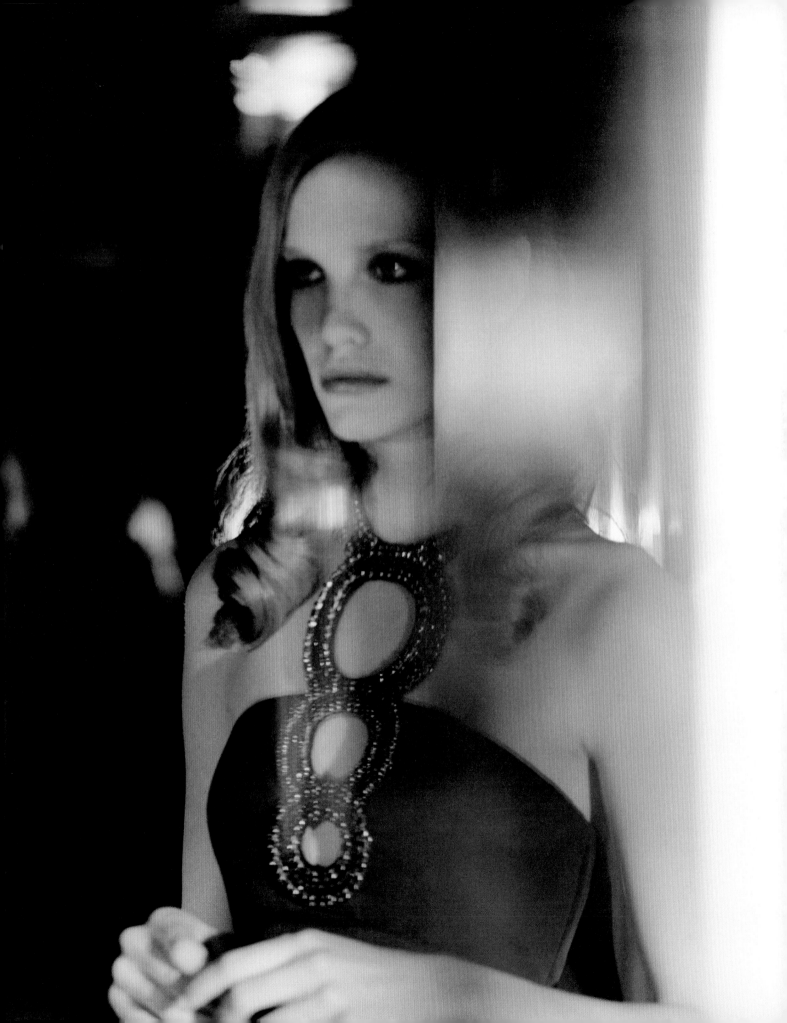

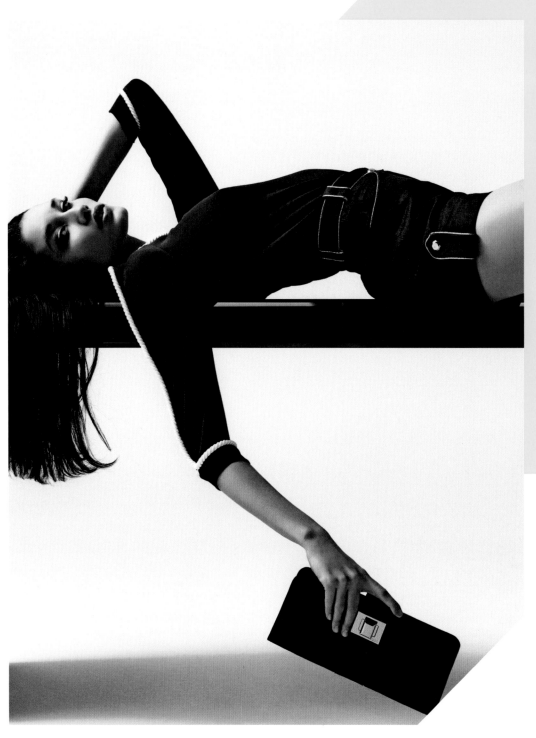

JUNIOR TOP AND *JEFE*
SHORTS. VANESSA SEWARD
FOR AZZARO, SUMMER 2011.

RIGHT: *PLUMETIS*
EMBROIDERED *JUNE*
DRESS. VANESSA SEWARD
FOR AZZARO, SUMMER 2011.

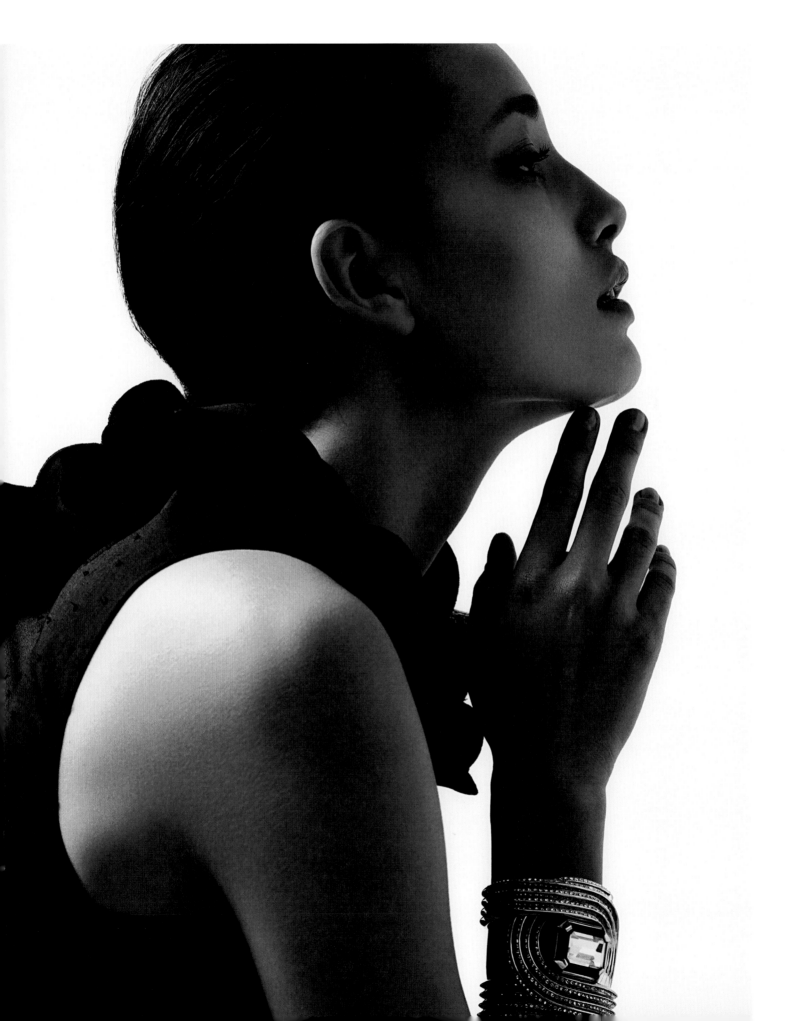

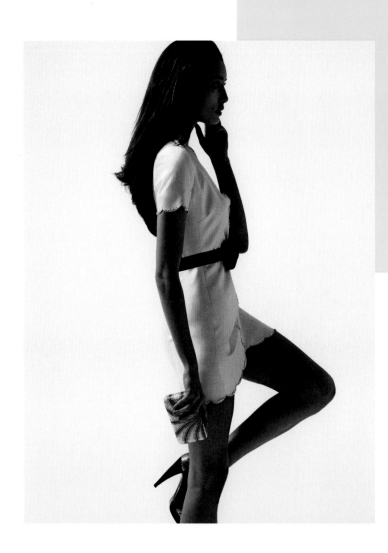

/ SILK SHANTUNG *JESSIE*
DRESS WITH VELVET AND
CRYSTAL EMBROIDERED BELT.
VANESSA SEWARD FOR AZZARO.

/ **RIGHT:** CREPE GEORGETTE
SWAROVSKI CRYSTAL-
EMBROIDERED V-NECK *JADE*
DRESS (VANESSA SEWARD FOR
AZZARO, SUMMER 2009)

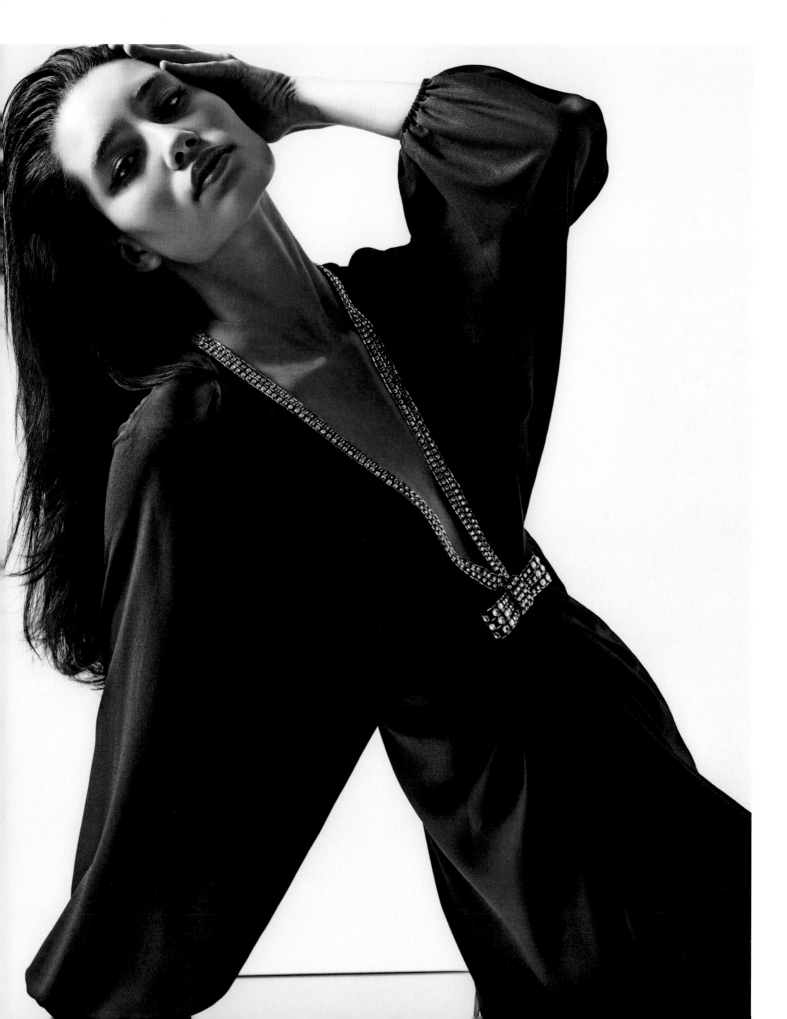

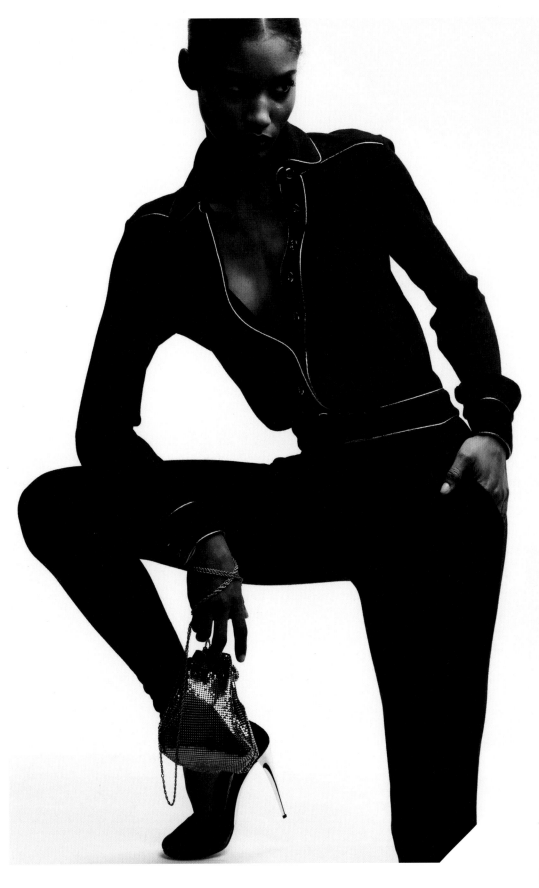

/ JERSEY *KOLIA* BOILER
SUIT WITH LAME PIPING.
VANESSA SEWARD FOR AZZARO,
WINTER 2011.

/ RIGHT: WOOL CREPE
SWAROVSKI CRYSTAL
EMBROIDERED *KAMILLE* DRESS.
VANESSA SEWARD FOR AZZARO,
WINTER 2011.

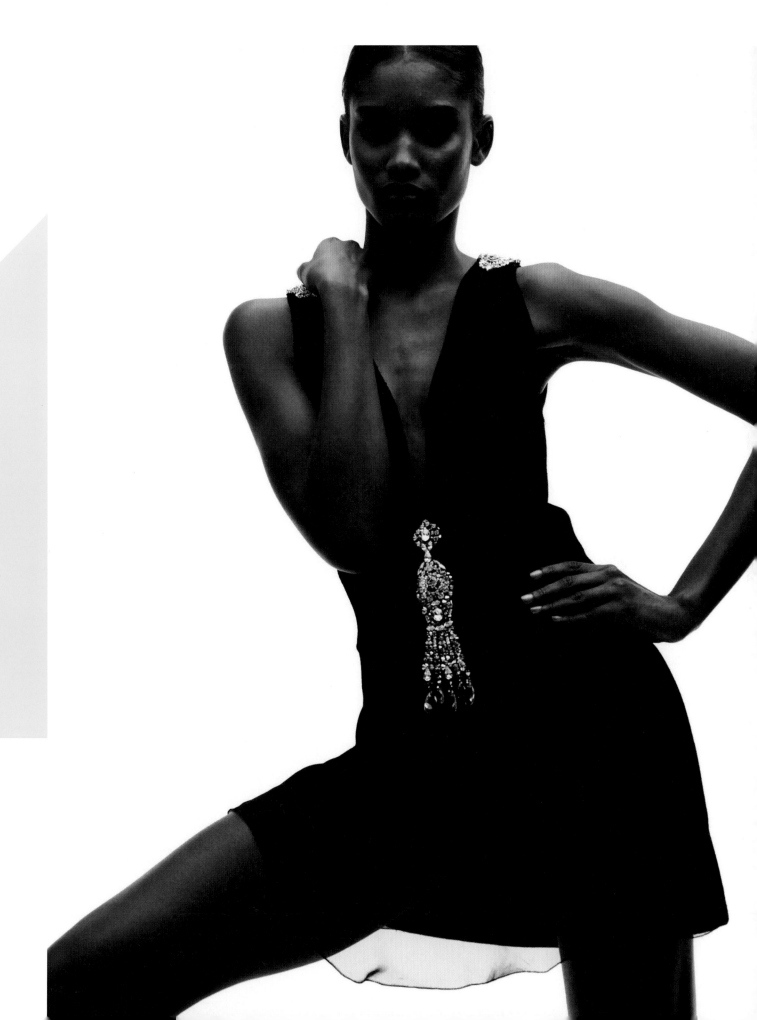

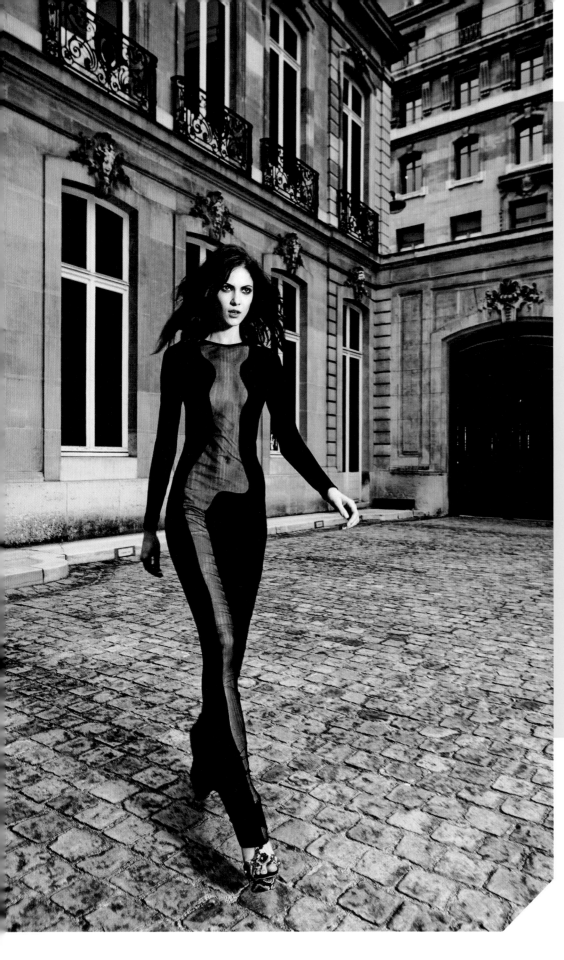

VISCOSE JERSEY AND CHIFFON *Paciane* DRESS. ARNAUD MAILLARD AND ALVARO CASTEJON FOR AZZARO, SUMMER 2014.

RIGHT: LUREX JERSEY *PIERANGELO* DRESS. ARNAUD MAILLARD AND ALVARO CASTEJON FOR AZZARO, SUMMER 2014.

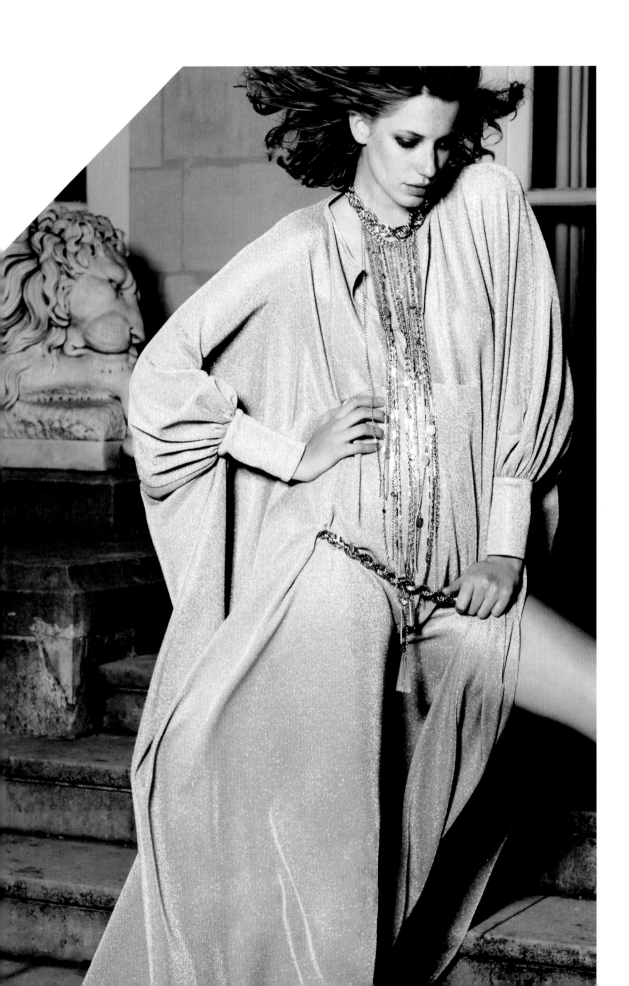

THE FIFTIETH
ANNIVERSARY SHOW

/ **RIGHT:** BIANCA
BRANDOLINI D'ADDA
AND EUGÉNIE NIARCHOS
MODEL SILK CHARMEUSE
ALVIRA PAJAMAS, SPRING/
SUMMER 2017.

To celebrate the legacy of the man who so loved women,
the fashion house on Rue du Faubourg Saint-Honoré wished
to pay tribute to the creator's iconic designs. The task was
entrusted to two long-time friends of the house, Italian fashion
model Bianca Brandolini d'Adda and Greek shipping heiress
Eugenie Niarchos. Eugenie, founder of the jewelry brand Venyx,
has already partnered with Azzaro on two jewelry collections
under the creative direction of Vanessa Seward. A regular
at fashion weeks, Bianca Brandolini d'Adda, daughter of
Brazilian countess and stylist Georgina Brandolini d'Adda,
has built up an impressive collection of vintage dresses over
the years, wearing them out to her many soirées. This marriage
between Italy and Greece would have surely pleased
the couturier, who lived and breathed the Mediterranean
and sensuality. Their modern take on these great classics
with the help of the studio and the ateliers exalts the festive
and carefree glamour that earned Azzaro its worldwide
reputation. Fifty years later, the spirit of Loris continues
to murmur its beautiful inner music as it floats through fashion,
elegance and Paris.

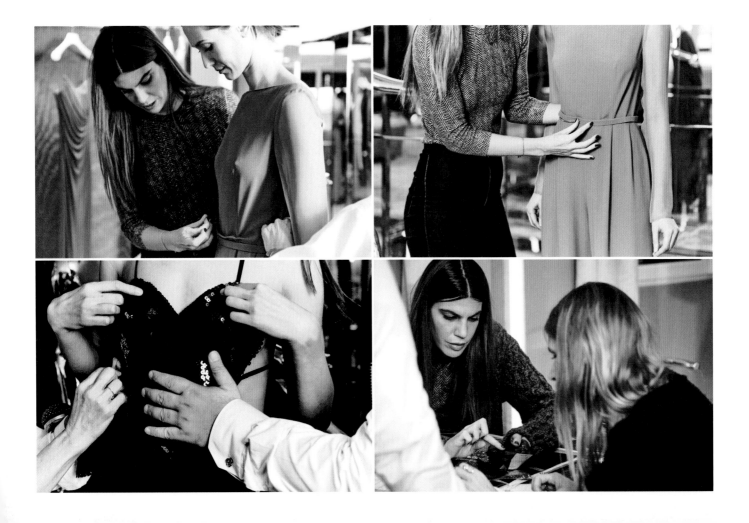

/ **TOP:** VISCOSE JERSEY
AMBRE DRESS, 50TH
ANNIVERSARY COLLECTION,
SPRING/SUMMER 2017.

/ **RIGHT:** EMBROIDERED
TULLE *AMAZONIA*
DRESS, 50TH ANNIVERSARY
COLLECTION, SPRING/
SUMMER 2017.

SATIN JERSEY *ARIZONA*
DRESS, 50TH ANNIVERSARY
COLLECTION, SPRING/
SUMMER 2017.

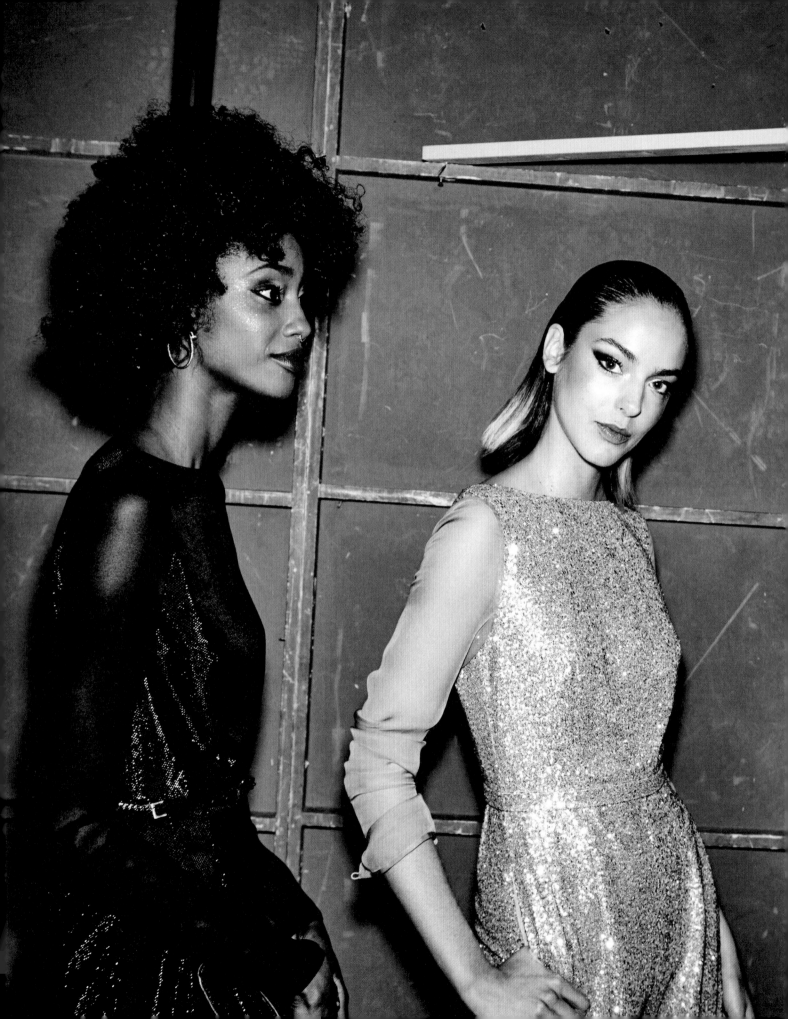

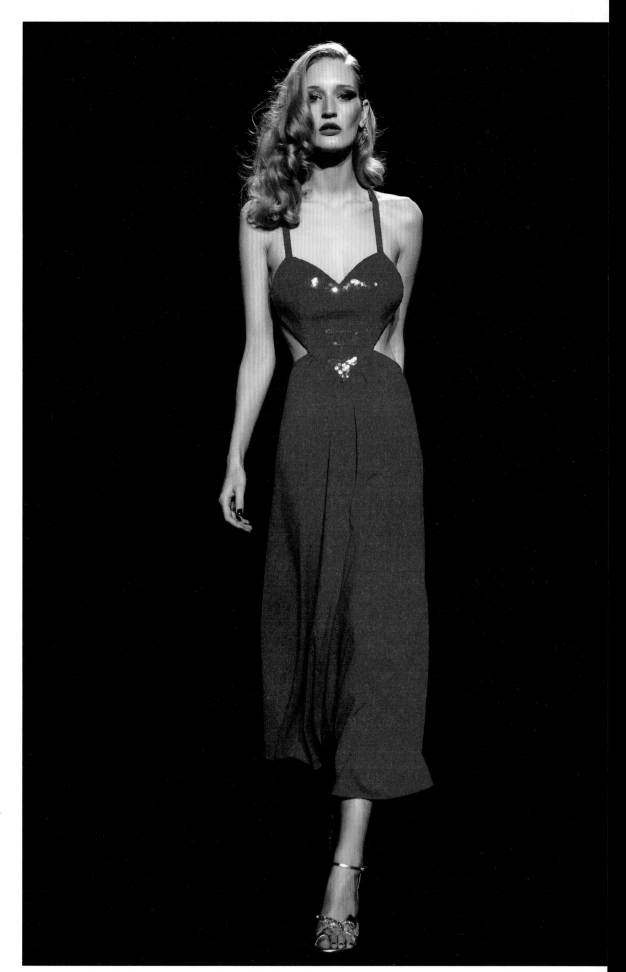

/ **LEFT:** STRETCH JERSEY *ARIA* BOILER SUIT (LEFT) AND SEQUIN JERSEY *ANJA* BOILER SUIT (RIGHT), 50TH ANNIVERSARY COLLECTION, SPRING/ SUMMER 2017.

/ **RIGHT:** JERSEY AND SEQUIN EMBROIDERED *AMORE* DRESS, 50TH ANNIVERSARY COLLECTION, SPRING/ SUMMER 2017.

MAXIME SIMOËNS
THE REVIVAL

For his first Azzaro collection, Maxime Simoëns has reinterpreted the codes of the House with a radical vision of couture that sweeps aside inhibitions and invites the Azzaro woman to express herself without restraint as a fun-loving, freewheeling heroine. In this way he pays homage to Loris Azzaro who made his name with the jewels that he created for his wife, then incorporated into his dress designs. It was this overspill of jewelry into couture that led to the jewel dresses of his first collections — jewels in their own right, with embroidered stones, crystals and beads underscoring the architecture of the design like touches of precious paint.

Thanks to this constant play of light, this delicate accenting of slender silhouettes, pure lines and flowing drapery, this first collection is resolutely modern — fluid, graphic, young and contemporary. A tad rebellious too, puffer jackets teamed up with evening gowns. Transparency creates a sense of edgy sensuality, showing off the body without ever stripping it naked, revealing a woman sure of her seductive powers.

PAGE 182:
BB CREPE MINI DRESS WITH SATIN LINING AND EMBROIDERED NECKLINE DETAIL. MAXIME SIMOËNS FOR AZZARO COUTURE, WINTER 2017.

PAGE 184:
BÉNITIER CHOKER-NECK DRESS. MAXIME SIMOËNS FOR AZZARO COUTURE, WINTER 2017.

PAGE 185:
BENGALE CRYSTAL-EMBROIDERED TASSEL DRESS. MAXIME SIMOËNS FOR AZZARO COUTURE, WINTER 2017.

PAGE 186-187:
BONTE SHIMMER, CRYSTAL-EMBELLISHED, DRAPED SATIN DRESS. MAXIME SIMOËNS FOR AZZARO COUTURE, WINTER 2017.

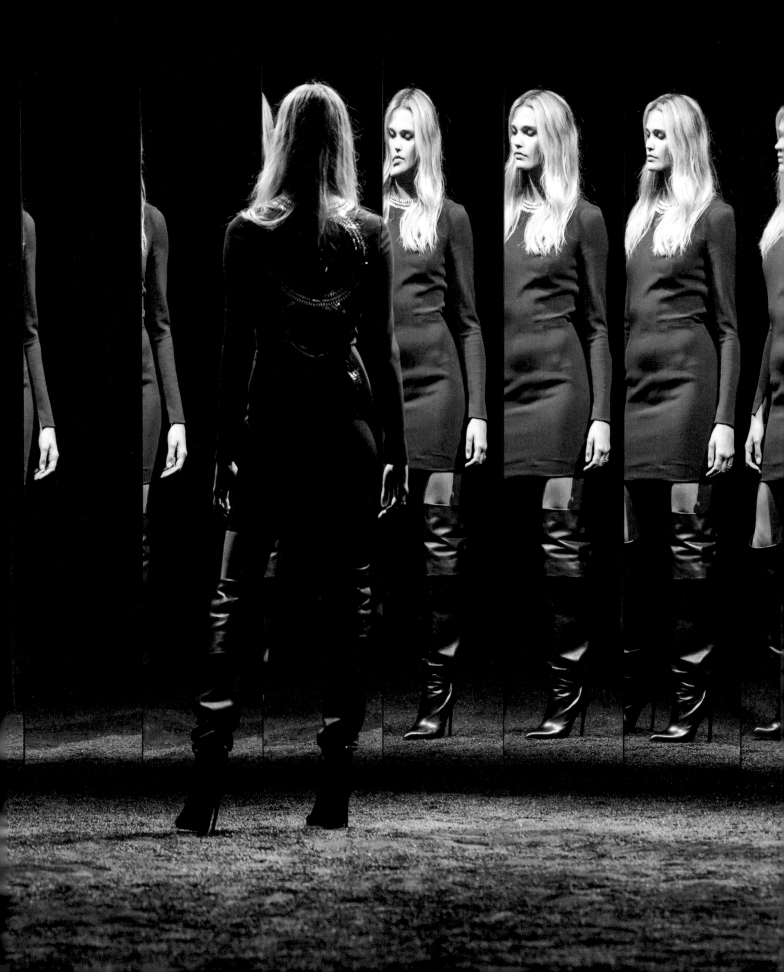

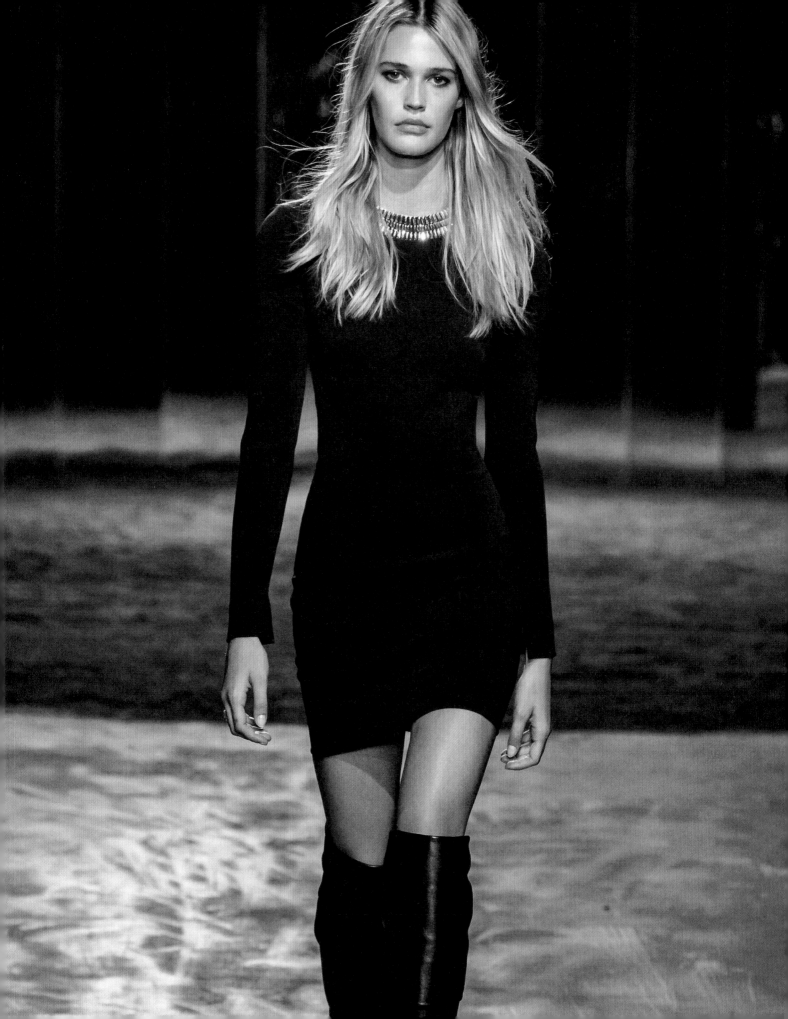

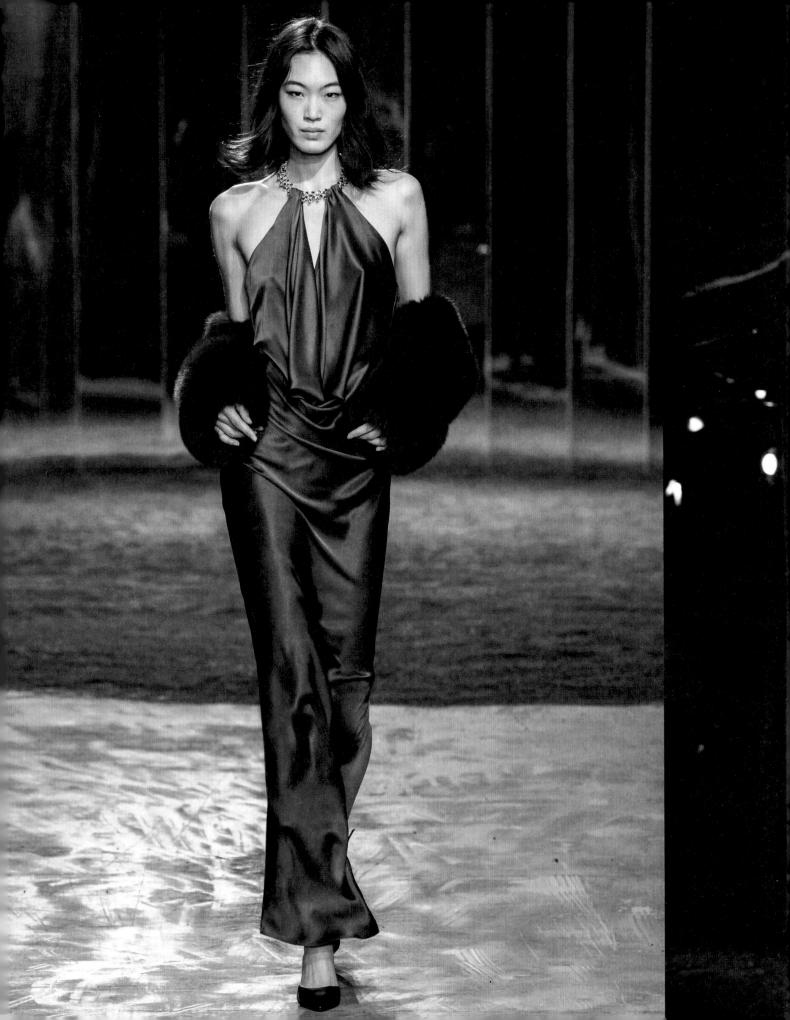

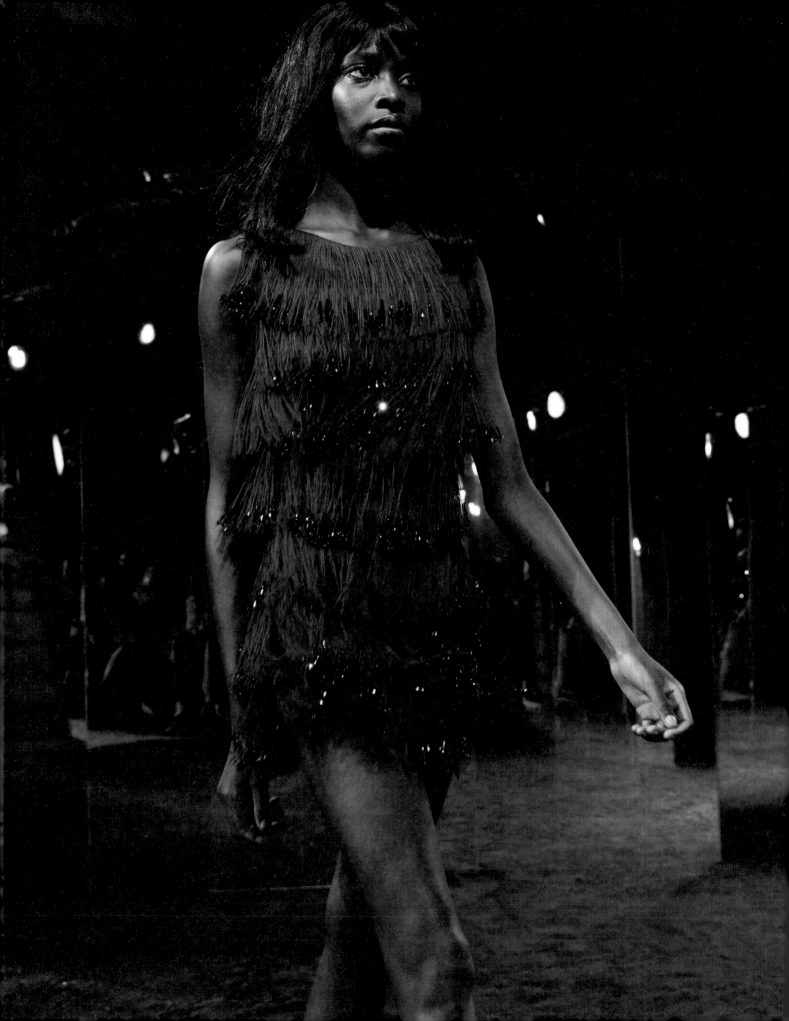

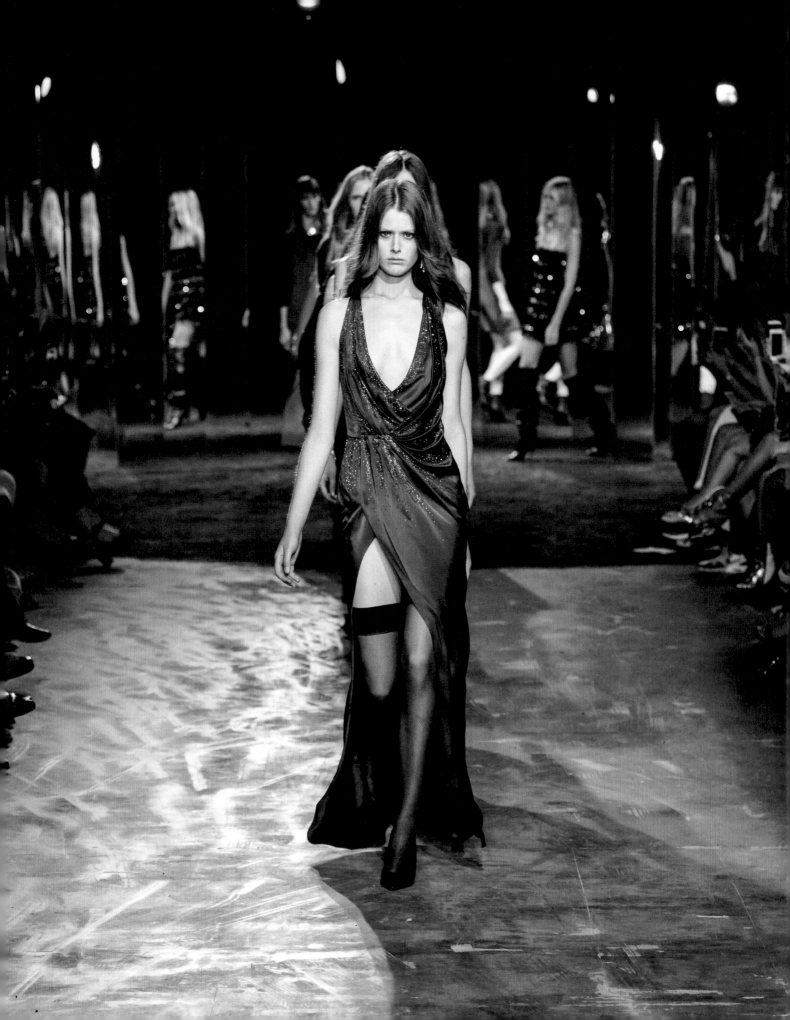

PHOTOGRAPHIC CREDITS

ACKNOWLEDGEMENTS

The author and the house of Azzaro especially thank
Béatrice Azzaro, Catherine Azzaro, Laura Azzaro,
Romain Azzaro, Pierre Aulas, Marisa Berenson,
Bianca Brandolini d'Adda, Christian Courtin-Clarins,
Olivier Courtins-Clarins, Gabriel de Linage,
Daphné de Saint Marceaux, Gérard Delcourt,
Sandrine Groslier, Reinhard Luthier, Eugénie Niarchos,
Fabrice Pellegrin, Carles Enseñat Reig, Maria Reig Moles,
Olivier Saillard, Dominique Salmon, Vanessa Seward,
Maxime Simoëns, Jean-Paul Solal,
Marie José Susskind Jalou, Patrice Vizioz.

Graphic design and art work: **Studio B49**
English translation: The foreword and chapters one to four were
translated by Marianne Lainé-Pereira (Badiane). Captions,
introductions to fragrances Azzaro Couture and Azzaro pour Homme
as well as the introduction to Maxime Simoëns, The Revival were
translated by Florence Brutton.

Library of Congress Control Number : 2017937190
ISBN: 978-1-4197-2879-2

Printed and bound in France by Imprimerie Escourbiac
10 9 8 7 6 5 4 3 2 1

ABRAMS